MINGEI
JAPANESE FOLK ART

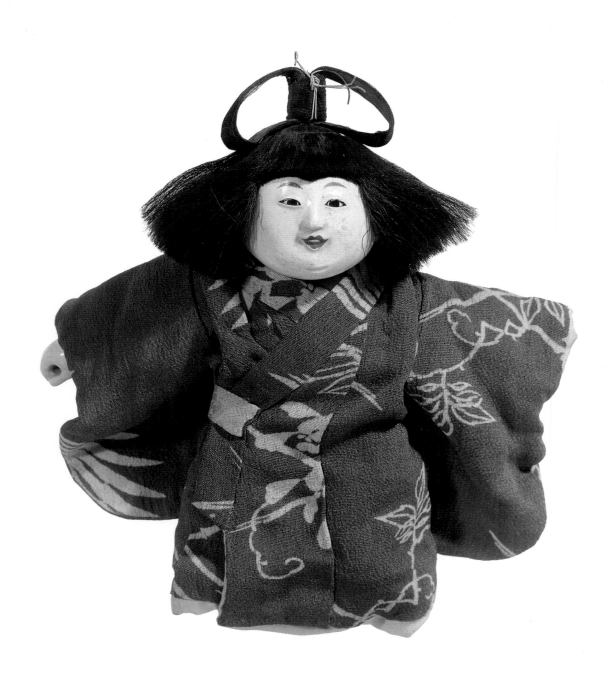

MINGEI
JAPANESE FOLK ART

FROM

THE BROOKLYN MUSEUM
COLLECTION

Robert Moes

Ainu Section by Anne Pike Tay

 UNIVERSE

NOTE: Items listed in the catalogue as loans are, without exception, promised gifts and will all enter the permanent collection of The Brooklyn Museum within a few years of this exhibition.

Cover illustration: **102. Bingata kimono**

Design by John Bellacosa

Published in the United States of America in 1985
by Universe Books
381 Park Avenue South, New York, N.Y. 10016

85 86 87 88 89 / 10 9 8 7 6 5 4 3 2 1

Printed in Japan

Library of Congress Cataloging-in-Publication Data

Moes, Robert.
 Mingei: Japanese folk art from the Brooklyn Museum collection.

 Bibliography: p.
 1. Folk art—Japan. 2. Brooklyn Museum. I. Brooklyn Museum. II. Title.
NK1071.M66 745'.0952 85-7502
ISBN 0-87663-481-1
ISBN 0-87663-881-7 (pbk.)

CONTENTS

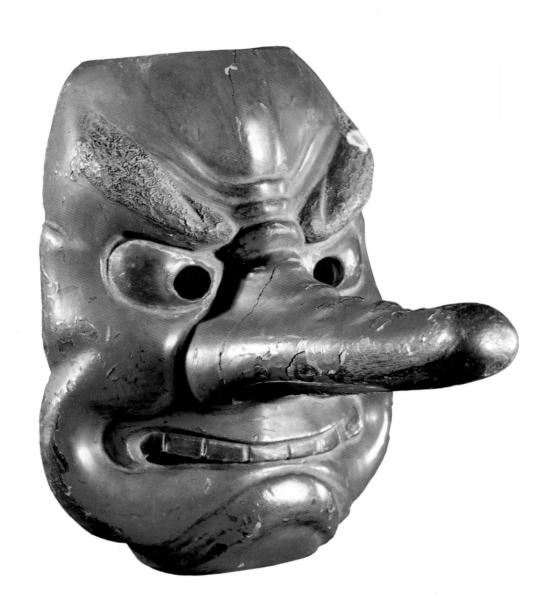

FOREWORD

This book originated as the catalogue of an exhibition of Japanese folk art held at The Brooklyn Museum from July 12th through September 30th, 1985. The Brooklyn Museum is perhaps unique in the United States in being able to assemble such a comprehensive exhibition of Japanese folk art from its own permanent collection. This is due in part to the resourcefulness of Stewart Culin (1858–1929), the Museum's Curator of Ethnology from 1902 to 1928. Culin acquired folk art at the source during two collecting trips to Japan in 1909 and 1913–14. At that time, Westernization had not yet caused the serious decline of traditional ways, especially in the countryside. Many of the artifacts now collected and admired as folk art were still in everyday use.

Not so today. The thatched roofs of the farmhouses have largely disappeared from Japan. There are, no doubt, a few deep in the mountains, but now a TV antenna surely sprouts from the ridgepole of every one. Inside even the most traditional Japanese house, electricity, kerosene, and propane have taken the place of wood, charcoal, and candles. Modern appliances, electronic gadgets, and plastic cutlery have replaced the old, handmade furniture and utensils.

The Museum's Curator of Oriental Art, Robert Moes, is especially well suited to write this catalogue. A specialist in Japanese art, he first visited Japan in 1963. At that time he got the feel of "Old Japan" by living for two years in a traditional Japanese six-mat *tatami* room with no Western-style furniture whatsoever. In those days very few Japanese families had television sets and there were almost no private automobiles in Japan. The changes that have taken place in Japan during the last twenty years are startling. Today there is a TV set in nearly every room of every Japanese house, and often two or three cars parked outside.

In 1963, the antique shops and used furniture stores in every Japanese neighborhood were filled to the ceilings with old Japanese folk art. Today these objects have almost all disappeared into museum and private collections.

One display case in the Japanese Gallery of The Brooklyn Museum has been regularly devoted to examples of Japanese folk art on a rotating basis. The richness and extent of the collection cannot be ascertained from this limited permanent display. We are extremely grateful to the National Endowment for the Arts for awarding us the "Utilization of Collections" grant that made this exhibition possible.

Robert T. Buck
Director, The Brooklyn Museum

PREFACE

The Brooklyn Museum was primarily a natural history museum until about 1930. At that time the Board of Governors decided to turn it into an art museum. During the changeover, stuffed animals, bones, and rocks were transferred to The American Museum of Natural History in Manhattan. However, a considerable amount of material originally collected as anthropological specimens was retained at The Brooklyn Museum as examples of primitive art or folk art.

The Japanese collection in the Department of Oriental Art contains a great deal of splendid folk art gathered by the noted anthropologist Stewart Culin on two collecting trips to Japan in 1909 and 1913–14. Culin was the indefatigable head of The Brooklyn Museum's Department of Ethnology until 1929.

The Department of African, Oceanic, and New World Cultures owns a comprehensive collection of Ainu artifacts acquired from Frederick Starr in 1912 as ethnographical material. The Ainu are Caucasian aborigines on Hokkaidō, the large northern island of the Japanese archipelago. While Ainu artifacts are not, strictly speaking, Japanese folk art, there is ample precedent for including a selection of them in this exhibition. The *mingeikan* (folk art museums) in Japan collect, study, and display Ainu artifacts, along with Japanese, Okinawan, and Korean folk art.

The Japanese folk art collected by Stewart Culin in Japan has been supplemented by several gifts received by the Department of Oriental Art during the 1930s, 40s, and 50s. During the last ten years, gaps in Brooklyn's Japanese folk art collection have been systematically filled with objects acquired through both purchase and gifts. Today this collection is one of the most comprehensive in the United States, one of the only ones capable of sustaining a major exhibition without borrowing from outside sources.

INTRODUCTION

THE APPRECIATION OF FOLK ART IN JAPAN

The Japanese have never recognized the basic distinction between "art" or "fine arts" (painting, sculpture, architecture) on the one hand, and "crafts" or "applied art" (ceramics, metalwork, textiles, woodwork, lacquer, basketry, paper, etc.) on the other, that we make in the West. This distinction is, after all, really quite an arbitrary one. The Renaissance ideal of the artist as a unique individual whose divinely inspired talent sets him apart from other men, and far above mere craftsmen, never occurred to the Japanese. The concept was introduced to Japan by Westerners during the latter part of the 19th century. Prior to that, the Japanese considered artists to be craftsmen whose trade happened to be the production of paintings, Buddhist sculpture, or buildings.

If our Western distinction between art and crafts is based on whether the product is utilitarian or not, then why is architecture "art"? A building is a utilitarian object to be lived in, worked in, or worshiped in. Even a painting or a sculpture is a utilitarian object in the sense that it is hung on the wall or placed on a pedestal to be looked at. Of course, the painting or sculpture is also meant to be contemplated for its aesthetic and spiritual qualities. But some of the best craft products also sustain this kind of contemplation, which the Japanese place great importance in and have a special term for: *biteki kōsatsu* (aesthetic contemplation).

Our own culture has produced an abundance of well-designed and skillfully fabricated handmade objects, which, though anonymous and utilitarian, are beautiful to look at and a pleasure to use. Equating crafts with art is peculiar but not entirely unique to Japan. The early Bauhaus, from 1921 until its move from Weimar to Dessau in 1925, taught that crafts and art are equal and the same.

In approaching a culture different from our own, we should exercise a little humility. We should try to find out how Japan views its folk art rather than apply our own arbitrary standards of judgment. The Japanese are justly famous for their keen sense of design and their sensitive response to natural materials, and they have produced more splendid craft products than most other cultures. However, we should not allow ourselves to be carried away by romantic reverence. Japan has obviously produced more than its share of junk, especially its cheap export goods. Thus each piece of Japanese folk art should be judged on its own merits. The best old Japanese craft objects often possess extraordinary beauty in their line, form, color, texture, and suitability to their function. Fortunately, many superb Japanese craft traditions have been lovingly maintained or revived and still produce excellent work today.

Before modern times, the Western-style concept of art simply did not exist in Japan. The idea was first introduced by Westerners in 1871. Two new Japanese words, *bijutsu* (art) and *geijutsu* (the fine arts), were coined at that time. Previously, the Japanese had taken their own arts and crafts for granted, regarding them merely as various skilled trades.

Japan had dwelled in self-imposed isolation for over two hundred years. By 1639, all foreigners except a small number of Dutch and Chinese were excluded; the Chinese were confined to the city of Nagasaki and the Dutch to their trading station on the artificial island of Deshima in Nagasaki harbor. The Japanese themselves were forbidden under penalty of death to travel abroad. Then in 1853, U.S. President Millard Fillmore sent Commodore Matthew Perry to reopen Japan. Perry arrived with a fleet of sail-and-steam warships and delivered a letter to the Shōgun demanding that foreign ships be allowed to stop at Japanese ports for water and supplies. Perry promised to return the following year. He came back in 1854 with seven ships and held a series of talks wtih Japanese officials. A treaty was negotiated, and two Japanese ports were opened to American ships. The English, Russians, and Dutch soon signed similar treaties. Foreign settlements with consulates were established at Shimoda, Yokohama, Kobe, Nagasaki, and on the northern island of Hokkaidō.

Foreign trade increased dramatically now that the Dutch and Chinese monopoly was broken. Prices went up drastically in Japan because certain products were exported in such quantity that shortages occurred at home. Cheap manufactured goods imported from industrialized Western countries were sold for less than their handmade Japanese equivalents, decreasing demand for many Japanese products and causing unemployment. Dissatisfaction with the government became widespread. The Japanese felt humiliated that "foreign barbarians" were able to impose their will on the helpless nation. In its fanatic desire to maintain the status quo in order to insure the survival of its regime, the Tokugawa government had failed to keep pace with foreign shipbuilding and armaments.

By the mid-19th century, Europe and America had gone through the industrial revolution, but Japan remained a medieval, feudal country that had changed little since the early 17th century. Samurai still wore two swords; their troops were still armed with spears and matchlock guns copied from those first brought by the Portuguese in the mid-16th century. There were no effective coastal defenses at all.

Not long after Perry's visit, warriors loyal to the emperor led a successful revolt against the Shōgun and restored administrative authority to Emperor Meiji in 1868. Meiji was a man of great insight and ability who was convinced of the need for a strong central government and rapid modernization. He carried out a series of essential administrative reforms that brought about profound social changes. Japan became a modern, industrial nation almost overnight, surely one of the most rapid and dramatic transformations the world has even seen.

Thus Japan's industrial revolution occurred during the years immediately following the Meiji Restoration. The Japanese government invited European and American engineers to set up Western-type factories for mass production. Ceramics, for example, which had formerly been handmade, were now mass produced. A German chemist, Dr. Gottfried Wagner, introduced commercial European ceramic production methods to Japan starting

in 1868 and built several large European-type kilns in the Tokyo area from 1882 to 1885.

In the first decade of the Meiji Period, Japan invited and received a massive influx of Western culture, then made a determined effort to master it. Unfortunately, during this initial phase, the Japanese tended to reject their own cultural heritage. Traditional craftsmen found little demand for their work; many were forced to abandon their hereditary family trades and take factory jobs.

Modernization and Westernization nearly destroyed the traditional Japanese crafts. Before the Meiji Restoration, craft production was a local activity. Each town produced its own specialities, using its own style and its own techniques. The craftsmen of one village worked in relative isolation from those in another. Each *daimyō* (feudal ruler of a province) jealously guarded the technical secrets of the craftsmen in his fief, since his clan held the monopoly on distributing their wares. When the Meiji government abolished feudalism in 1871 and replaced the provinces with modern prefectures, Japanese craftsmen found that much of their market and its distribution system had been abruptly eliminated. Many craftsmen were suddenly without a livelihood.

Fortunately, Japanese participation in international expositions helped create a foreign demand for Japanese goods and provide jobs for Japanese craftsmen. At the Paris Exposition of 1867, the San Francisco Exposition of 1871, the Vienna Exposition of 1873, and many subsequent ones, the Japanese exhibits were fully subsidized by the Meiji government. Japanese officials and craftsmen traveled to the expositions to study the Western market and learn Western manufacturing techniques. For example, on their return from the Vienna Exposition, two Japanese potters introduced the use of plaster molds for slip-casting ceramics.

Enthusiastic Western response to Japanese goods at the international expositions helped encourage the revival of craft production in Japan. So did expositions at home, such as the National Industrial Fair at Tokyo in 1877. The imperial household stimulated the creation of high-quality arts and crafts through frequent purchases for its collection.

Eager to strengthen Japan's economy, the Meiji government commanded the production of certain crafts, especially ceramics, lacquer, ivory carving, and cloisonne, for the foreign export market. Rapidly expanding foreign trade created a huge demand for export items. Such goods were called *hamamono* (the *"hama"* of *"*Yokohama*"* and *"mono"* meaning "things"), since Yokohama was the main port through which they were shipped abroad. Unfortunately, these export handicrafts were at the opposite pole of taste from the simple, functional beauty of traditional Japanese crafts that we admire today. *Hamamono* were created specifically to suit Victorian Western taste. They are usually maudlin in their decorative over-elaboration and simpering, anecdotal romanticism. Victorian eclecticism also exerted an inevitable and unfortunate impact on Meiji crafts. Vessel shapes began to suffer from inconsistency and lack of restraint: European styles from classical antiquity to Art Nouveau were indiscriminately combined on a single piece and even mixed with traditional Chinese and Japanese forms. Complex landscape and figural scenes in the European academic style were applied to the surfaces of many pieces. Even more

unfortunately, in their desire to be modern, the majority of the Japanese themselves began displaying this kind of Victorian clap-trap in their own homes; many continue to do so today, just as we do in the West. But at least this kind of junk provided jobs for numerous artisans and kept some of the old techniques alive.

Rapid industrialization following the Meiji Restoration resulted in a temporary blurring of the distinction between crafts and industry. The word "crafts" ("kōgei") was extended to mean "industrial technology." The government viewed crafts as a branch of industry and encouraged its adaptation to mass production for both the export and domestic markets. Mass production encouraged standardization, so the unique character of each district's crafts began to disappear. Artists were called in to design crafts and supervise their decoration. Individual craftsmen no longer created their own distinctive pieces. Handmade items were gradually replaced by machine-made ones that could be sold more cheaply. In accordance with European practice, crafts were now regarded as inferior to art. In 1907 the government art exhibitions ceased including crafts at all.

By the second decade of the Meiji Period, a reaction to Westernization set in. Many Japanese statesmen, intellectuals, and artists asserted that the imitation of foreign ways was demeaning; Japan must build on its own great traditions. Westernization was viewed as contrary to Shintō, Buddhist, and Confucian teachings. In the visual arts, the earlier progress toward mastering Western styles was nearly obliterated by this surge of nationalism.

In the third Meiji decade, an equilibrium was reached between pro-Western and pro-Japanese artists in Japan, and a healthy balance has been maintained between the two factions until the present day. The Meiji government was directly involved in developing and controlling the arts and crafts through its selection of curriculum and faculty at the government universities, as well as its sponsorship of art and craft exhibitions both at home and abroad.

Thus did industrialization and Westernization practically destroy the traditional crafts of Japan. They were saved from oblivion at the very last moment through the efforts of one man, Yanagi Sōetsu (1889–1961). Yanagi, a philosopher turned literary and art critic, founded the Crafts Movement in Japan. He taught the Japanese to respect and enjoy good, traditional handmade objects again. He helped rescue traditional craft techniques from extinction. And through his compelling book, *The Unknown Craftsman*, he showed the West how to appreciate good Japanese crafts.

The Crafts Movement in Japan was a counter-industrial revolution parallel to the Arts and Crafts Movement in England, which, in fact, had provided the inspiration for it. Like his mentors John Ruskin and William Morris, Yanagi sought a return to the beauty of handmade objects, to the greater fulfillment of the craftsmen in their production as well as the greater satisfaction of the consumers in their use. It is interesting that the Crafts Movement in Japan achieved a more widespread and lasting succes than its counterpart in England.

Yanagi was a remarkable man. His brilliant writings on various artists and mystics of the Western world served somehow to deepen his apprecia tion of traditional Japanese and Korean crafts. Born in Tokyo, Yanagi was

educated at the Peers School and Tokyo Imperial University, where he received a degree in philosophy. In 1910 he and his friends, some of whom were members of the old Kyoto court nobility and later became well-known writers, started a monthly magazine called *Shirakaba (White Birch)*. This journal led the field in introducing Western literature, art, and philosophy to Japan. Yanagi was one of its chief editors as well as a frequent contributor. He was especially interested in the English mystic William Blake and the American poet Walt Whitman. He published a major book on the former in 1914 and a magazine devoted to the two in 1929–30. Among his many other achievements, Yanagi was a professor at Dōshisha University in Kyoto and lectured on Buddhist art and aesthetics at Harvard in 1928–29. As the guiding theoretician of the Crafts Movement in Japan, Yanagi wrote voluminously on the subject of traditional crafts.

In 1918 Yanagi invited the English potter Bernard Leach to build a kiln on the Yanagi family estate at Abiko, 25 miles east of Tokyo. Leach was originally a painter but came to Japan in 1909 and studied ceramics under Kenzan VI. When he opened his own ceramics studio in 1912, Leach was ridiculed for throwing his own pots. The Japanese believed that an artist-potter should create the designs and apply the decoration; throwing was to be done by lowly assistants. However, Leach's insistence on producing the entire piece himself eventually prevailed in Japan; serious Japanese potters now do their own throwing and trimming.

Leach stayed at Abiko for a year. He and Yanagi often discussed the problems created by the transition from local folk crafts to modern industrialization, and the emergence of the self-conscious individual artist. Yanagi was inspired by William Morris's Arts and Crafts Movement in England, but he discovered there was no word in the Japanese language for "folk art." The word *kōgei* (crafts) was not much help because it had recently acquired the connotation of "industrial technology."

Before Westernization, the crafts in Japan were simply regarded as various trades, neither fine art nor folk art. The same was true of painting, sculpture, and architecture. Yanagi considered the work of humble, anonymous, traditional craftsmen superior to that of self-conscious artists because it was natural, direct, and unself-conscious. In the early 1920s, he invented an entirely new Japanese word for folk art — *mingei* (art of the common people).

In 1926 Yanagi and two friends, the potters Hamada Shōji and Kawai Kanjirō, founded the Japan Folk Art Association (Nihon Mingei Kyōkai), with Yanagi as president. The Association's journal, *Mingei (Folk Art)*, began in 1931 with Yanagi as editor and is still published today. In 1936 the Japan Folk Art Association established the Japan Folk Art Museum (Nihon Mingei Kan) in Tokyo, with Yanagi as director. The Museum now has branches in Kurashiki, Tottori, and Osaka.

Yanagi's Crafts Movement in Japan has been a phenomenal success. Most modern Japanese respect, if they do not always revere, handmade objects. They usually display a few such pieces in their homes, although most of what they use every day is, of course, factory made. There is an active, steady demand for handmade crafts in Japan, so that large numbers of craftsmen in a wide variety of fields can make decent livings without resorting to teaching or other outside work. Japanese collectors pay high prices for good examples of antique Japanese folk art. Several American

museums have responded to it, most notably the Peabody Museum in Salem, Massachusetts, the Seattle Art Museum, the Cleveland Museum of Art, and The Brooklyn Museum.

One of the ironies resulting from the success of the Crafts Movement in Japan is that the production of Japanese folk art itself has recently become too commercial. Skillful care in workmanship and freshness of design are often lacking, yet these are the very qualities that give such crafts their reason for existing. While still handmade, many of the pieces are now virtually mass produced. Before the Meiji Period, each district, often each village, had its noted local product (*meibutsu*). Nowadays, these local distinctions often disappear. Whatever craft product is currently in demand is produced at several scattered locations, many of which had no such local tradition in the past. But at least traditional techniques are being kept alive, and many craftsmen are still quite conscientious, producing much excellent work even today. Since 1955, the Japanese government has sought to encourage artists and craftsmen by honoring a few of the best with an official title that is popularly called Living National Treasure (*Ningen Kokuhō*).

Another irony applies to Yanagi himself. His achievement was certainly significant and commendable: He taught us to see the beauty in good handmade objects. Yet when one reads *The Unknown Craftsman*, one discovers that Yanagi took his theories too far. He concluded that humble, anonymous crafts are *superior* to works by famous artists, whom he considered self-conscious, egotistical, and dependent on the whims of their spoiled, aristocratic patrons. We need not take this part of Yanagi's teaching too seriously, for it would mean rejecting most of the masterpieces of world art

CHARACTERISTICS OF JAPANESE FOLK ART

The period of production for Japanese folk art is mainly the Edo Period (1615–1868) and the Meiji Period (1868–1912). Earlier material has not survived in sufficient quantity because of its utilitarian status and generally perishable materials. Buddhist and Shintō art treasures were preserved in the storehouses of the great monasteries and shrines. Classical art produced for the imperial court nobility or the military aristocracy was preserved in palace or mansion storehouses. The silk kimono, gold lacquer, paintings, and tea-ceremony utensils of rich merchants were likewise preserved in family *kura* (storehouses). But folk art was used until it broke or wore out, then it was thrown away and forgotten. Only pieces from more recent centuries have tended to survive.

Efforts to make valid generalizations about anything as diverse and complex as Japanese folk art are probably doomed to failure. The subject includes painting, sculpture, ceramics, furniture, wooden utensils, ironware, brass and copper work, signboards, lacquer, basketry, weaving and dyeing, leather, papermaking, papier mâché, and toys. Numerous exceptions to any generalizations will inevitably arise, and so attempts to find explanations for these generalizations will be even more difficult. Nevertheless, anyone hoping to interpret the subject for those unfamiliar with it is obliged to try.

Japanese folk art is produced by anonymous craftsmen for everyday use by ordinary people and may be distinguished by directness, unselfconsciousness, ruggedness, simplicity, spontaneity, naiveté, joy, strength, richness, vitality, harmony, asymmetry, informality, sensitive use of inexpensive natural materials, and appropriateness to intended function.

Another characteristic of Japanese folk art is localism. Each province, and ultimately each town, had its own way of doing things. Until modern times, communication within Japan was not easy. The many rivers and bays, the Inland Sea, and the oceans surrounding Japan did provide a network of waterways for commerce and travel, but they broke Japan up into a profusion of separate islands and districts. Broad plains and rolling hills occur in certain places, but much of the islands' surface is taken up by rugged mountains that further divide the country into small pockets.

In feudal Japan, from the late 12th century through the mid-19th, there were formidable political and military barriers as well. The sixty-eight provinces were often at war with one another, and even in times of peace they were competitive and jealous of each other. Travel between provinces was restricted by the government. The resulting situation was not detrimental to the arts and crafts, however. Instead, it nourished an incredible variety of vigorous local traditions. Even today, each prefecture and nearly every town has its *meibutsu* (famous local product), which Japanese travelers bring home as obligatory *omiyage* (souvenir gifts).

Japanese folk art has an admirable freshness, simplicity, and directness that make it quite appealing to those of us who admire contemporary Western art and design. In good Japanese folk art, form follows function. Even in a folk painting, where there is no physical function, superfluous elements are kept to a minimum. This resulted partly from the necessity to hold costs down; the consumers of Japanese folk art were mostly people of

modest means. But it also resulted from the Japanese sense of design, which is probably more developed than that of any other people.

Buddhism came to Japan from India by way of China and Korea in the mid-6th century. Japan accepted the religion but rejected the Indian preoccupation with spiritual values and the Indian idea that reality is illusory. Chinese pragmatism is altogether different from Indian denial of the physical world. Japan borrowed heavily from Chinese culture but never acquired the Chinese tendency to intellectualize things. The Japanese remained more intuitive and emotional, preferring to deal with things directly rather than to philosophize, to accept things the way they are and enjoy them for what they are. This directness is one reason why the Japanese sense of design is so acute. A Japanese artist or craftsman goes directly to the formal aspects of his work; he does not get encumbered in its literary freight. He takes shapes and motifs from nature and renders them in simple, stylized, asymmetrical, harmonious, imaginative ways. He paints with line and flat areas of color and does not model in light and shade for an illusion of volume as we do in the West. He also eschews the deep spatial recession and enveloping misty atmosphere of Chinese paintings. The Chinese conceit that only painting and calligraphy constitute art and that painting must carry literary allusions never penetrated Japan. The Chinese have always admired good porcelain but do not consider it to be art. The Japanese regard a good ceramic as a work of art every bit as significant as a good painting.

Another key to the high quality of much Japanese folk art is the age-old Japanese love of natural materials, especially wood. The Japanese craftsman uses these materials in a direct and highly sympathetic manner to exploit and enhance the color, texture, and grain rather than to refine them beyond recognition.

Just as the brightly polychromed gold screen paintings of 16th- and 17th-century Japan are the antitheses of the Zen-inspired monochrome ink-wash paintings of the 14th to 16th centuries, so the 17th-century Tokugawa mausoleums at Nikkō are the antitheses of Japanese folk art. Where folk art is straightforward, functional, and sensitive to its materials, Nikkō is famous for the most ornate wooden architecture in the world. Nearly every inch of its surface is covered with the most elaborate, high-relief carving, all painted in bright colors, black lacquer, and gold.

Nevertheless, it would be inaccurate to say that the innate aesthetic sensitivity of the Japanese tends toward either the gaudy and ostentatious (*hade*) or the simple and understated (*shibui*). Both extremes of taste are equally characteristic of Japan, with a continuous range between. They have existed side by side throughout most of Japan's history, and are not separated by wealth or status; people of all classes have always responded to both. Thus the unadorned directness of Japanese folk art is typical of only one aspect of Japanese taste, albeit the one with which the contemporary Westerner is most comfortable.

The Japanese admiration for wood, as well as related materials like bamboo, paper, and straw, has a long history. A corollary of it is the Japanese reverence for the effects of wear and age on natural materials. The columns and beams of old Japanese temples are left weathered to a velvety gray color rather than periodically repainted the original cinnabar red. Similarly, utensils whose outer layer of red lacquer wore through in places

to the black lacquer undercoat from years of use came to be much admired in Japan. Thereafter, a whole lacquer tradition (*negoro*) developed in which the red outer coat was intentionally rubbed through to the black here and there as part of the manufacturing process. Tea-ceremony influence caused the phenomenon of artificially induced wear to become a significant aspect of Japanese culture.

Enjoyment of mellow, well-worn furnishings is certainly not unique to Japan. A crusty New Englander usually prefers his American Windsor chair with most of its paint worn off from years of loving use. However, this kind of attitude has been more widespread and constant in Japan than elsewhere in the world, amounting at times to almost a cult.

The Japanese tea ceremony, primarily an activity of the military aristocracy and wealthy merchant families, codified this preference for wear and age. It advocates *sabi* (patina, age, simplicity) and *wabi* (choosing the understated and inexpensive instead of the ostentatious and costly but utilizing them in a highly creative way).

Japanese folk art is the opposite of the tea ceremony in both its patronage and its basic attitudes. It was the art of the common people rather than of the samurai and merchants. The unself-conscious, naive directness of folk art contrasts with the highly sophisticated refinement of the tea ceremony. Nevertheless, the admiration for and sensitive use of ordinary natural materials is common to both folk art and tea ceremony. It is a significant characteristic of the Japanese temperament.

This respect for and enjoyment of natural materials may be interpreted as an aspect of Shintō, the indigenous religion of Japan. Shintō itself is in part an expression of appreciation and respect for the generally hospitable environment of the Japanese islands. According to Shintō mythology, the islands were created by the gods and the Japanese are descended from the Sun Goddess. Shintō is an ancient, animistic belief; it teaches that a *kami* (sentient spirit) dwells in every rock, tree, mountain, or blade of grass.

A Japanese craftsman working with wood never rakes and scratches its surface with rasps and sandpaper. Instead, he trims it to its final form with razor-sharp planes and draw-knives. This produces a velvety smooth and absolutely flat surface that permits the color, texture, and grain of the wood to speak for themselves. Similarly, a Japanese sword polisher does not scratch up the steel surface with emery paper or steel wool, nor does he buff it to a high gloss with a cloth wheel and polishing compound. Instead, he cuts directly across the crystalline structure of the steel surface with finer and finer grades of flat limestone polishing stones. This is an extremely meticulous and time-consuming process, but it permits the grain and temper pattern of the steel to show in a way that would be impossible with any other technique.

Japanese respect for the craftsman and his work is also related to the Shintō appreciation of nature. The craftsman's product is a modified natural substance: Iron-bearing river sand plus charcoal fire becomes a sword; mud plus pine fire becomes a pottery bowl. The *kami* (spirit) of the forge or kiln participates in the craftsman's work, so offerings of wine, rice, and mandarin oranges are placed on a small shrine shelf attached to the kiln or above the forge.

Japanese respect for craftsmen also derives from a well-developed Japanese empathy with ordinary people. It is also the result of a conservative

social system in which the relationship between a craftsman and his apprentices was nearly as important and strict as that between a samurai and his retainers. The apprentices gained a deep knowledge of their craft and acquired a legendary technical skill through years of mandatory training. Only when technique becomes second nature is true creativity possible. Japanese professionalism is completely at variance with the Chinese ideal of the artist as a scholarly amateur.

Appreciation of art, including folk art, is more widespread among the general population of Japan than in most other countries. The Japanese have an inherent capacity to enjoy art. Shintō reverence for nature helps sustain their awareness of artistic beauty. The Buddhist concept that life in this world is transitory serves to heighten the Japanese response to beauty. Because beauty is fleeting, it is all the more poignant and beautiful. It is therefore all the more important to enjoy it while one can. Zen Buddhism, although quite different from other Buddhist sects, teaches a spontaneous, intuitive, immediate awareness of reality. This reinforces the Japanese tendency to respond to art directly, intuitively, and enthusiastically.

The tea ceremony is extremely self-conscious and perhaps excessively refined, while folk art is unself-conscious, utilitarian, and plebeian. They are almost direct opposites. Yet one is tempted to draw a parallel between them, and the point seems relevant. These two traditions, both characteristic of Japan, yet so unlike each other in most ways, are similar in one respect: Each of them has elevated ordinary utilitarian objects to the realm of art, even to the highest realm of art, although for completely different reasons.

Starting around the middle of the 16th century, Japanese tea masters began to reject the lavish, expensive, imported Chinese utensils formerly in favor with their aristocratic and powerful patrons. Instead, they selected "found objects" from among the inexpensive, ordinary utensils used every day by the common people. Instead of Chien-yao teabowls, Lung-ch'uan celadon flower vases, Ming Dynasty tea caddies, and carved cinnabar lacquer trays, the tea masters selected Korean peasant rice bowls (*Ido chawan*) and used them as teabowls. Japanese peasant storage jars were adapted as flower vases. The next step was to commission peasant potters to produce pieces directly for use in the tea ceremony.

Inexpensive, ordinary materials were chosen for the construction of the teahouse: wood, bamboo, paper, straw, and mud plaster. The tea masters developed an aesthetic theory explaining that humble utensils and common materials selected for the tea ceremony are far more beautiful, more spiritually profound, and therefore more appropriate, than expensive, elaborate ones. Zen teachings played an important role in all this; Zen was the preferred sect of the military aristocracy who were the main early patrons of the tea ceremony. Yanagi Sōetsu's elevation of anonymous folk art to a position above that of great works by famous artists is surely parallel to the tea ceremony's raising of humble peasant wares to the highest realm of art, and probably could not have happened without it.

MINGEI: JAPANESE FOLK ART

PAINTINGS

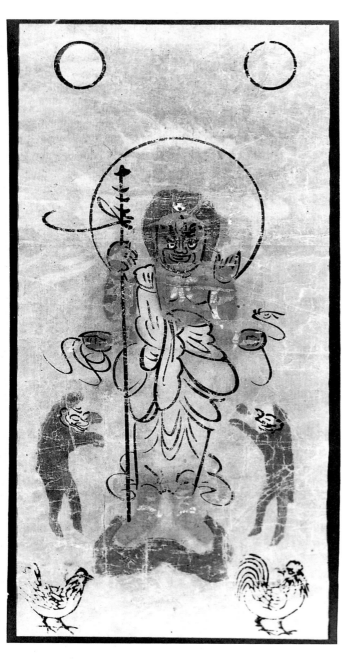

1. Shōmen Kongō

Ōtsu-e, ink and color on paper
H. 14¼", W. 6⅞" exclusive of mounting
Edo Period, 17th century
Walter Bogert Fund 51.236

Ōtsu, a town on the shore of Lake Biwa, was the last stage station on the Tōkaidō highway from Edo (modern Tokyo) to Kyoto. There were fifty-three such post towns along the Tōkaidō between Edo and Kyoto, made famous in Hiroshige's great 1834 set of fifty-five prints called *The Fifty-three Stages of the Tōkaidō*.

From the early 17th century through the middle 19th, the *meibutsu* (famous local product) of Ōtsu was *Ōtsu-e* ("e" here means "picture" or "painting"). *Ōtsu-e* were anonymous folk paintings of popular religious or secular subjects, sold as *omiyage* (souvenir gifts) to pilgrims and other travelers passing through the town on their way to or from Edo.

Shōmen Kongō is an especially appropriate subject for an *Ōtsu-e* because this deity protects travelers against evil spirits. He has a green body, four to six arms, three red eyes, and a flaming halo. He was originally a demon who ate humans, but he converted and became a guardian against demons, among whom he causes plagues. Here he is shown worshiped by two monkeys. On the "night of the elder monkey" each year, an all-night vigil was held in hopes of preventing certain spirits from leaving each person's sleeping body and going up to heaven to report his evil deeds. Shōmen Kongō became associated with this originally Taoist practice and his painting was hung during the vigil.

While the rest of this picture is hand painted and perhaps partly stenciled, the rooster and hen at the bottom are each printed individually with a separate woodblock in order to save time. They are present here because a rooster's crowing at dawn was once thought to drive away the evil spirits of the night. The sun and the moon are represented at the top of the painting.

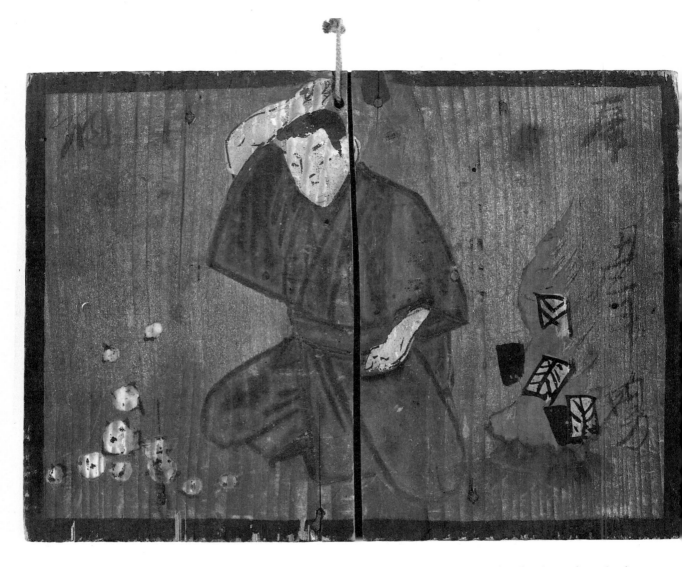

6. Gambler

Ema, ink and color on *sugi* (cryptomeria) wood
H. 6″, W. 8⅜″
Meiji Period, 19th century
Gift of Dr. & Mrs. John Lyden 84.139.17

The kneeling gambler has built a bonfire to burn up his playing cards and is smashing his dice to bits with a hammer — obviously a sore loser. Since an *ema* was given to a shrine or temple either when praying for a favor or expressing thanks for a favor already received, this fellow is either asking the gods to help him kick the gambling habit or else thanking them for having done so. He is *not* asking them to help him win at gambling; if that were so, he would not be destroying his cards and dice.

This painting is an example of *ko-ema* (little *ema*), small mass-produced pictures which were sold cheaply to the throngs of ordinary people coming as pilgrims or worshipers to the large religious establishments. This *ema* is also an example of the kind of secular, prosaic subject matter one often finds in *ema* after they became popular with the masses.

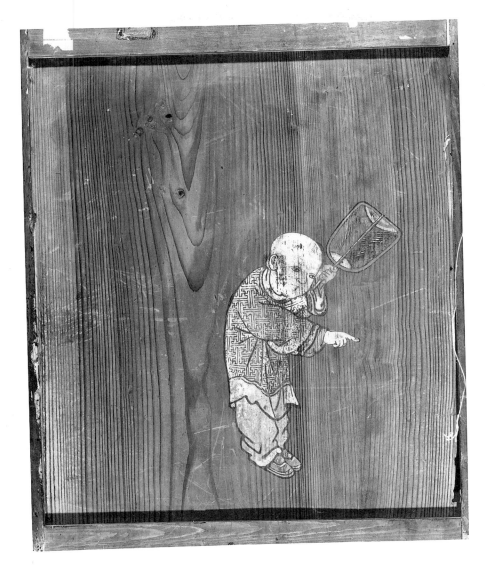

7. Karako

Itado, ink and color on *sugi* (cryptomeria) wood
H. 24", W. 20¾"
Edo Period, 18th century
Gift of Dale Jenkins 84.192.3

Karako means "Chinese child." *Kara* is actually the Japanese pronunciation of the ideogram for the T'ang Dynasty (618–907). Since the T'ang was an especially great dynasty and had tremendous cultural impact on Japan, *kara* came to mean "China" in general. *Ko* means "child," of either sex, but in fact *karako* are in-variably depicted as male children and are shown wear-ing the imaginary clothing and coiffure of the Chinese nobility.

Karako are an extremely common motif in the paintings and decorative arts of China, Korea, and Japan. The motif is an auspicious one, symbolizing an abundance of sons and grandsons, and their success in life. The Tokugawa government installed as its official philosophy a modified version of Chinese Confucianism, according to which, it is the duty of every wife to produce male children. If she does not, the fault is always assumed to be hers; her husband and his family will scorn her.

According to the mystical ideals of Chinese Taoism, a man who is blessed with numerous sons and grandsons achieves a kind of immortality. And, of course, he enjoys a happy old age, attended to by his offspring, especially if they have achieved great success in their own lives, as suggested by the courtly costume in which *karako* are always dressed. Here the boy holds an *uchiwa,* a Chinese-style (nonfolding) fan. Although countless elements of Japanese culture were borrowed from China, the typical, pivoted, folding fan was invented by the Japanese and copied by China.

An *itado* is a wooden sliding door, either one of a pair of full-size doors blocking the outside entrance to the veranda of a traditional Japanese house, or else, as here, a small one for a built-in cupboard in the *tokonoma* (decorative alcove) of a formal Japanese room. The opaque paper-covered sliding doors separating the rooms of a Japanese house are *fusuma,* and of course, the translucent paper-covered sliding doors on the outer side of a Japanese room are *shōji.* A bronze *hikite* (finger catch) for opening and closing it may be seen on the frame of this cupboard door.

Like *fusuma, itado* formed an inviting surface for paintings. Even famous artists sometimes did them. However, the little boy we see here is rendered in the broad, slightly naive style of a folk artist. With *ema* (see cat. 3 through 6), the surface of the board was customarily covered with gesso and white paint, although this has often weathered away. With *itado*, however, it was traditional to paint the subject directly on the wood surface, allowing the beautiful cryptomeria grain, with its alternating zones of thin, parallel stripes and broad curving V's to show clearly.

MINGEI: JAPANESE FOLK ART

SCULPTURE

8. Kannon Bosatsu (The Bodhisattva Avalokitesvara)

Stele, gray granite
H. 51", W. 19"
Edo Period, dated in accordance with 18 February 1663
Gift of Doris Wiener 83.175

A Bodhisattva is a Buddhist being who has stored up enough spiritual merit through selfless acts in countless reincarnations to achieve Buddhahood himself, but who has chosen to stay behind in this miserable world in order to help others achieve salvation, putting off his own final enlightenment until all the sentient beings in the universe have been saved. Kannon (Sanskrit: Avalokitesvara; Chinese: Kuan-yin) is the most merciful, and therefore the most popular, of the Bodhisattvas. In Japan, Kannon was especially prominent in the Pure Land Sects, where he helped convey the souls of deceased believers to the Pure Land, that is, the Western Paradise of Amida (the Buddha Amitabha). The Pure Land Sects made salvation extremely easy for everyone. Since to guarantee rebirth in paradise, it was necessary only to utter Amida's name in good faith once during a person's lifetime, these sects became the most popular and wealthy Buddhist sects in Japan.

The diminutive figure of Amida Buddha usually found in the diadem of a Kannon image is not present here. However, the crown and the relatively elaborate, full-length drapery (the imaginary garments of an Indian prince, like those of Prince Siddhartha before he became the Buddha Sakyamuni) identify this image as a Bodhisattva, the incised *bonji* (Japanese version of a sanskrit letter) *sa* at the top center of the boat-shaped body halo indicates he is one of the thirty-three manifestations of Kannon. The Japanese inscription along the left edge of the halo is the date of dedication: Kambun san (3d year of the Kambun Era) Kibō-reki (cyclical year indicator) Nigatsu jūhachinichi (18 February). The figure stands on a plinth in the shape of a lotus blossom.

The figure, halo, and plinth are all made from one large piece of gray granite. Unlike India and China, the volcanic Japanese islands have not yielded large quantities of sandstone, limestone, or marble suitable for sculpture. But they do have an abundance of hard, coarse granite, which is ideal for temple foundations and other architectural uses but is just too tough and coarse grained for finely detailed sculpture. Therefore, nearly all of the classic Buddhist sculpture of Japan has been done in wood or, to a lesser extent, bronze. But wooden images would be quickly ruined if placed outside and exposed to the weather. Since it is practically indestructible, the native granite proved ideal for outdoor monuments such as stone lanterns or the sculpture for cemeteries and open roadside shrines. Thus a whole tradition of outdoor granite folk sculpture developed in Japan.

Granite lends itself to the broad, rugged style of folk artisans, the same stonecutters who carved temple lanterns and tombstones, as opposed to the *busshi*, or professional Buddhist sculptors, who produced wood images for the interiors of temples. Many of the *busshi* became quite famous; they often signed their work, unlike the anonymous craftsmen who chiseled the granite

The principal production center for granite sculpture was Sado Island, in the Japan Sea off the north coast of Honshū, the main island of Japan. In the old days, Sado Island was sufficiently remote that criminals and political prisoners were banished there to work in the gold mines and granite quarries. The winters on Sado are particularly severe, with large quantities of snow deposited by icy winds blowing down from Siberia. Granite images and stone lanterns remain an important Sado Island product today.

Since Kannon helps convey the souls of dying believers to the Western Paradise of Amida, a large stone image of Kannon such as this would have been especially appropriate for placement in one of the extensive cemeteries within the precincts of a major Pure Land Sect temple, where the ashes of pious monks and important lay devotees are buried.

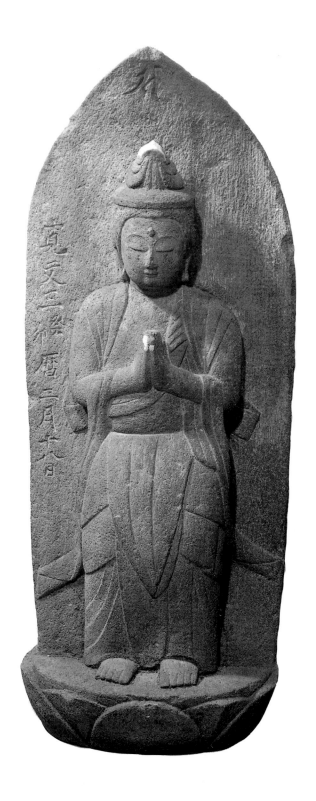

寛文三年癸卯暦二月十六日

33

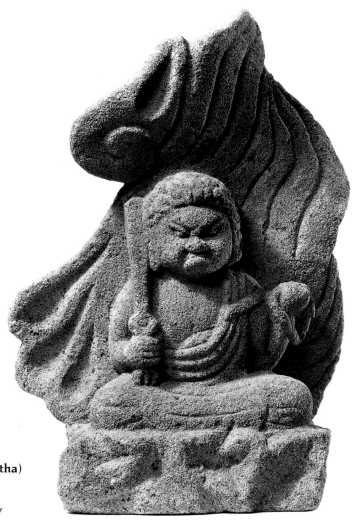

9. Fudō Myōō (Acalanātha)
Small stele, gray granite
H. 16½", W. 10½"
Edo Period, 18th century
Purchase 75.128.3

Fudō is the most important of the Godai Myōō, The Five Great Bright Kings, popularly called The Five Terrible Ones, a group of fierce, militant Buddhist guardian deities. Fudō has an appropriately angry expression and two fangs protrude from his lips. He holds a rope to bind the forces of evil and ignorance and a sword with which to slay them. He is surrounded by a halo of fire and sits on a rock precipice. His name literally means "The Immovable."

Fudō's militant wrath is directed only toward evil spirits and enemies of the church; toward true believers he is always compassionate and protective. He is called

"The Champion of the Righteous" and is worshiped as a god of wisdom and the divinity of waterfalls. Even his rope lasso is utilized compassionately: to catch the wicked and pull them over to the side of true knowledge.

Stone images of popular Buddhist deities such as th stood out in the open or under rudimentary shelters a roadside shrines by the intersections of old country roads or along the stone walkways of sprawling temp precincts. Devout Buddhist travelers or pilgrims mad simple offerings to these images and prayed to the div nities they represented for special favors or protectio

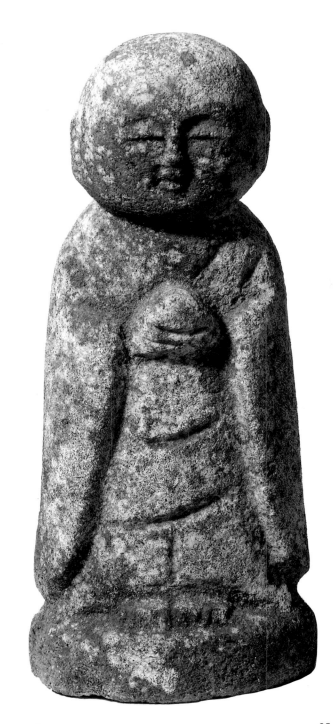

10. Jizō Bosatsu (The Bodhisattva Ksitigarbha)
Gray granite
H. 6¼", W. 2¾"
Edo Period, 18th–19th century
Gift of Dr. & Mrs. John Lyden 84.139.14

Jizō is the only Bodhisattva not depicted in the
crown, jewelry, and complex drapery of an Indian
prince. Instead, he is portrayed as a Buddhist monk,
having a shaved head and wearing a simple monk's
robe. Because he has several important functions, Jizō
is the second most popular Bodhisattva in Japan after
Kannon. Jizō rescues the damned from Hell; he is also
the guardian deity of children and the patron saint of
travelers. More formal images show him holding a
Buddhist monk's iron staff, which he uses to batter
down the doors of Hell. In his other hand he holds a
Flaming Jewel, the symbol of Buddhist wisdom, with

which to light the darkness of the underworld. In this simple folk image he clutches the Flaming Jewel to his chest.

Tiny granite images of Jizō like this are still a *meibutsu* (famous local product) of Sado Island today. Their form and style have changed little through the centuries. As with nearly all granite figures that stood outdoors, this Jizō has acquired a marvelous patina from the moss and lichen growing on its surface (Japan is extremely moist during the rainy season in July and August).

Small stone figures such as this were purchased by individual devotees and kept for protection. The figure was placed in a *butsudan* (small, portable Buddhist shrine) in the home, set up outside in the garden beside the house, or deposited on the base of the family tombstone at the local cemetery.

Because of their role in protecting travelers, larger granite images of Jizō were extremely prevalent at roadside shrines in the old days. Today, one still finds them clustered in open subsidiary shrines within the precincts of major Buddhist temples. Pilgrims and worshipers tie biblike cloth aprons, usually bright red, around the necks of stone Jizō figures as an act of devotion, as in the group of one hundred Jizō images at Kiyomizudera in Kyoto. The idea of increasing the number of images in order to multiply their spiritual and magical efficacy is characteristic of Buddhist thinking in India and elsewhere.

MINGEI: JAPANESE FOLK ART

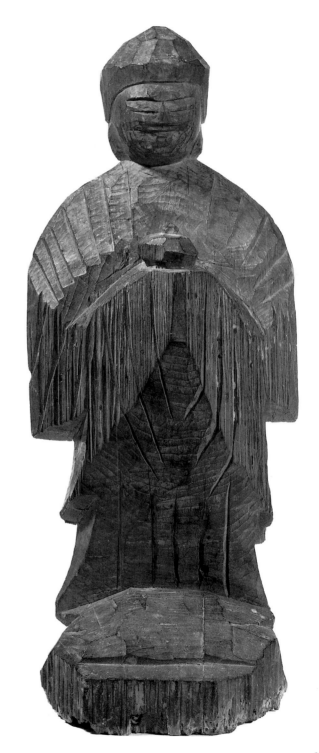

11. Yakushi (Bhaishajaguru)
By Enkū (1632–95)
Hinoki (Japanese cypress)
H. 17", W. 6½"
Gift of Allen and Susan Dickes Hubbard 83.167

Yakushi is the Buddha of Healing; he has special powers for curing illnesses and healing injuries. Such services being always in great demand, Yakushi was extensively worshiped in Japan. He is identified here by his usual attribute, the ointment jar he holds in his hands, which contains medicine to heal all mankind. On the back of this rough-hewn wood image is a two-line invocation written with a brush and ink in *bonji* (Japanese pseudo-Sanskrit letters), accompanied by the

artist's signature written in regular Chinese / Japanese characters: Enkū Saku (Made by Enkū).

Enkū was an itinerant beggar-monk and *busshi* (Buddhist sculptor), but even though he was not an anonymous craftsman, the wood images he carved may be classified as folk art for two reasons: First, unlike the *busshi* who produced formal, elaborate, hieratic wood images for major temples, Enkū worked in a simple, broad, rough style called *natabori* (hatchet carving). Second, he gave away the majority of his carvings to the common people, who have treasured and worshiped them for the past three hundred years.

Enkū was born to a poor family in central Japan, not far from the city of Nagoya. He entered a village temple as a student monk while still in his teens but left that monastery at the age of twenty-three. He subsequently became a lifelong adherent of a syncretic religious discipline called Shugendō. Shugendō combined elements of Japanese esoteric Buddhism, Shintō, and mountain shamanism with Chinese Taoist medical magic and divination. Shugendō required frequent periods of rigorous ascetic training and austerities in remote mountain areas. In 1679 Enkū was initiated as a monk of Tendai, one of the main Esoteric Buddhist sects.

Enkū traveled all over central and northern Japan, going as far as the Tōhoku region of northeastern Honshū and even across to Hokkaidō, the large northern island. Hokkaidō was extremely remote in those days. While there, Enkū preached and taught among the Ainu aborigines, who revered him as a Buddha incarnate. It was customary for villagers to offer itinerant priests food and shelter. Wherever he went, Enkū carved and gave away his rough wooden images to the local temples, shrines, or villagers who took him in.

As Enkū's free, joyous, vigorous style of image-making matured, the act of carving seems to have coalesced with the act of prayer. He worked hard all his life ministering to the spiritual needs of the common people and carving images for them.

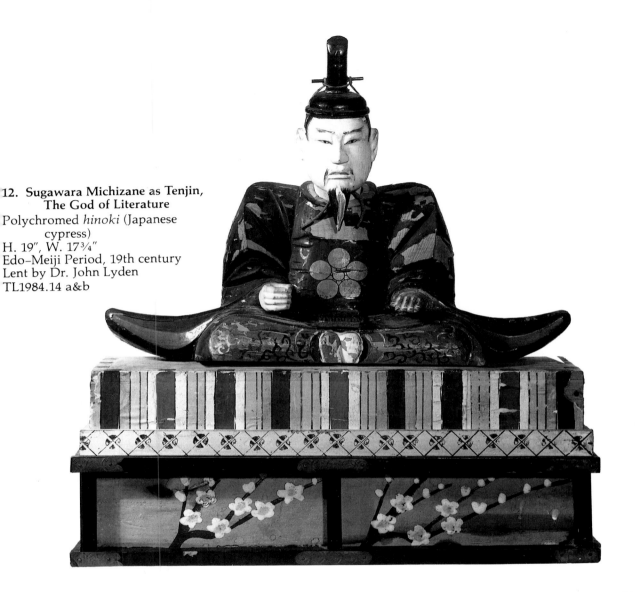

**12. Sugawara Michizane as Tenjin,
The God of Literature**

Polychromed *hinoki* (Japanese
cypress)
H. 19″, W. 17¾″
Edo–Meiji Period, 19th century
Lent by Dr. John Lyden
TL1984.14 a&b

Here Michizane sits in the formal posture of a court nobleman attending an imperial audience; deified as a Shintō god, he is receiving the worshiper in audience, so to speak. He wears the same formal court attire we saw in the Ōtsu-e painting of him (see cat. 2), black-lacquered horsehair-mesh court cap, court robe, and *hakama* (skirtlike formal trousers). The *mon* (family crest) on his chest is a stylized plum blossom. He originally wore a court sword at his left waist and held a *shaku* (baton of office) in his clenched right hand.

The bright stripes on the upper part of his pedestal represent the colorful cloth binding on the tatamilike cushions courtiers sat on during the Heian Period when Michizane lived. The branches of blossoming plum painted on the front of the dais refer to Michizane's great fondness for the plum trees in the garden of his Kyoto court mansion.

A wonderfully naive and primitive religious sculpture like this would have been made for the worship hall of some country temple or for the *kamidana* (household shrine shelf) in the kitchen of some well-to-do villager.

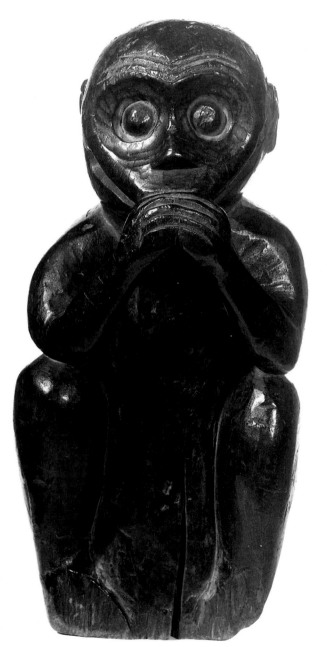

13. Iwazaru ("Speak No Evil" Monkey)

Hinoki (Japanese cypress)
H. 8¾", W. 3½"
Edo Period, 18th–19th century
Gift of Mr. & Mrs. Horst Kleindienst 83.239.2

Sambiki Saru, the Three Monkeys ("See no Evil," "Hear no Evil," and "Speak no Evil") became familiar to most Americans through cheap souvenirs imported from Japan before World War II. Nearly every American tourist to visit Japan has seen the most famous set of the Three Monkeys, carved in high relief above the door of the Stable for the Sacred Horse at Nikkō. This Shintō shrine complex, called the Tōshōgū, was built during the second quarter of the 17th century as the mausoleum ot Tokugawa Ieyasu; it is the most elaborate wooden architecture in the world.

"See no Evil" holds his hands over his eyes, "Hear no Evil" holds his hands over his ears, and "Speak no Evil" holds his hands over his mouth, as we see here. The Three Monkeys are the attendants of Kōshin, also called Saruta Hiko no Mikoto, the Shintō God of the Roads. At Shintō shrines dedicated to this deity, old dolls are offered in memory of the departed. Offerings are also placed before rough granite images of Kōshin, and/or his Three Monkeys, at open-air shrines along old country roads. A wood image such as this would have formed one of a set of the Three Monkeys for a local Shintō shrine or for the shrine shelf (*kamidana,* literally "god shelf") in the home of some prosperous villager.

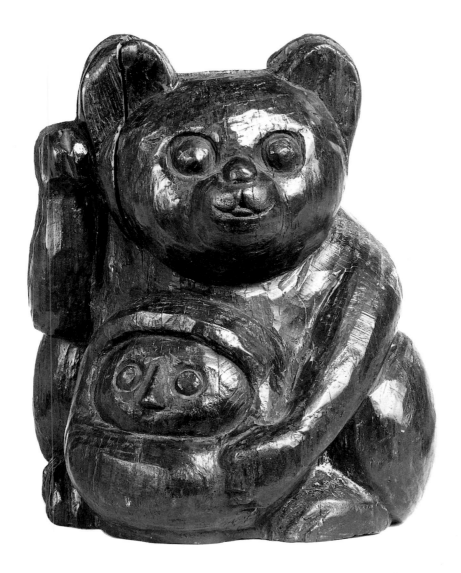

14. Maneki-Neko and Okiagari-Koboshi Daruma
Mold for a papier-mâché figure, *hinoki*
 (*Japanese cypress*)
H. 8¼", W. 7¼"
Edo Period, 18th century
Anonymous gift 74.52

Maneki-neko means "beckoning cat." In the West the gesture made by this cat's right paw signifies waving goodbye; in Japan it means the opposite: "Come here!"

When you hail a taxi in Tokyo you must remember to wave bye-bye instead of beckon. Papier-mâché (Japanese: *hariko*) or painted clay figures of *maneki-neko* have been extremely popular in Japan for centuries. Even today, nearly every Japanese shop and restaurant displays one. The reason is not far to seek. *Maneki-neko* symbolically beckons in good fortune, thus insuring the success of his owner's business.

Most *maneki-neko* figures have always been made of papier-mâché or clay, in either case painted with bright

colors. This wooden cat is, in fact, the mold for a papier-mâché one. A deep groove runs up one side, along the top, and down the other side; it is visible on the tips of the ears in this photograph. The wood mold was coated with grease so glue would not stick to it. Then it was coated with layer upon layer of glue-soaked scrap paper. When this dried, it formed a rigid shell. The craftsman cut along the groove with a sharp knife, separating the shell into a front and back half, and removed each half from the mold. The two halves were then glued together, forming a sturdy, hollow figure. Finally the surface was painted with bright colors.

Another type of papier-mâché figure has always been nearly as ubiquitous as *maneki-neko*: it is called *okiagari-koboshi Daruma*. Daruma (Sanskrit: Bodhidharma) is the legendary first patriarch of Zen Buddhism. He was supposedly an Indian monk who brought Ch'an (Zen) to China from India. In actuality, Zen never existed in India; it was developed in China by combining certain Indian Buddhist concepts with Chinese Taoist and neo-Confucian thought.

Bodhidharma is said to have achieved *satori* (Zen enlightenment) after staring at the wall of his cave for seven years. Along with numerous serious Zen paintings of him, the Japanese began centuries ago producing slightly satirical tumble-toy dolls of Daruma, wrapped in his hooded monk's robe, with his big eyes staring out, as if at the cave wall. *Okiagari-koboshi* means a Daruma tumble-toy, made of hollow papier-mâché weighted with clay at the bottom so it always returns to an upright position after being pushed over. The unusual, perhaps unique, feature of this wooden cat mold is that it combines the beckoning cat and Daruma doll in one figure. There is a symbolic parallel between the two, however. Daruma dolls are brightly painted, but their staring eyes are always left blank white. The purchaser of such a doll ceremoniously paints in the black pupil of one eye while making a wish, asking the gods for assistance in obtaining some favor. If the wish is granted, he traditionally paints in the pupil of the other eye, thereby thanking the gods for their help and symbolically restoring Daruma's sight. Japanese politicians who have won elections routinely perform this rite.

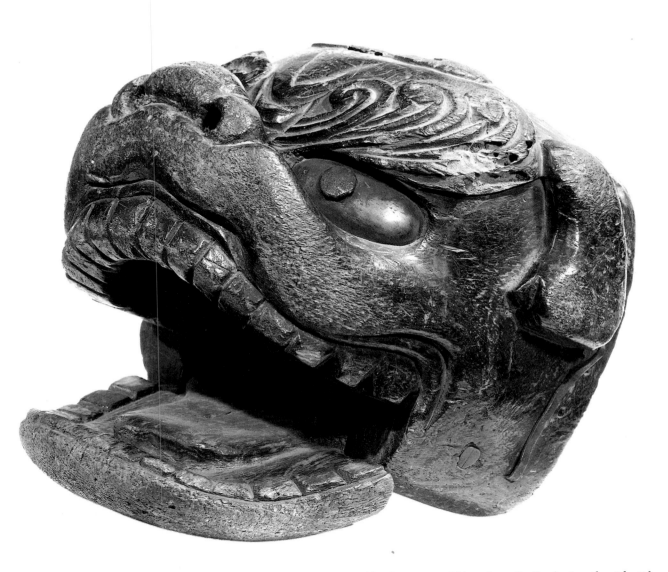

15. Shishi (Mythical Lion)

Mask, *kiri* (paulownia wood) with brass eyes and
 iron pupils
H. 5¾", W. 6½"
Edo Period, 18th century
Anonymous gift 47.219.62

The lion (*shishi*) motif came to Japan from China by
way of Korea; it is often called *karashishi* (T'ang lion
or Chinese lion). But lions are not native to China; the
motif had come to China from India during the 4th–5th
centuries in the service of Buddhism. The Buddha's
throne was protected by a pair of guardian lions. These
Indian Buddhist lions were already quite stylized, bear-
ing only a vague resemblance to the real animal. As
this imported lion motif was assimilated in China, it
also became secularized, and its form took on some of
the characteristics of the Pekingese dogs cherished by
the Chinese nobility. Hence Westerners often refer to
such mythical Chinese lions as lion-dogs or Fo dogs.

They have fierce expressions, large eyes, and curly manes. Stone or bronze ones stand guard at temples and palaces in China. Other examples gambol playfully among peonies, their favorite flowers, in Chinese paintings. The lion motif came to Japan with the introduction of Buddhism in the 6th century and gradually became secularized there also.

Japanese lion masks like this were used in the lion dance (shishi-mai). They always have hinged jaws. A lion mask was not worn on the face; it was held from inside by the outstretched hand of the dancer, whose arm served as the lion's neck. A second dancer provided the lion's rear legs; a cloth draped over the two dancers became the lion's body.

The lion dance, or the nearly identical dragon dance, is still popular in China for processions and festivals. This Chinese lion dance derives from court dance-dramas of the T'ang Dynasty (618–907); these, in turn, were influenced by Central Asian music and dance.

In Japan the lion dance became a folk tradition. It is still performed at various rural festivals. It is especially significant at New Year's, when the lion dances from door to door through a village, symbolically driving away the evil spirits at each house so the family can expect good fortune throughout the coming year. This practice is a vestige of ancient Japanese shamanism, some of which has survived in remote mountain districts.

The present lion mask is about half the usual size. The lion dance was sometimes performed by little boys who used this smaller-size mask. Lion masks of recent centuries are usually painted with bright red and black lacquer, but many of the older, more primitive ones have a natural dark brown finish made from a mixture of oil and lacquer, as we see here.

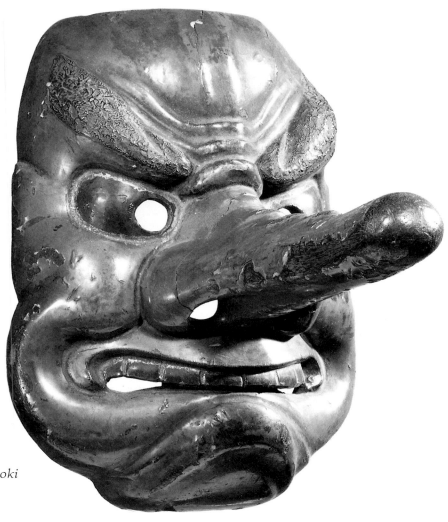

16. Konoha Tengu
Mask, red lacquer on *hinoki*
 (Japanese cypress)
H. 8¼″, W. 6¾″
Edo Period, 18th century
Purchase 28.743

Tengu are mythical beings who inhabit the remote mountain forests of Japan. There are two types. *Konoha tengu* look like humans but have extraordinarily long noses, as we see here. *Konoha tengu's* phallic nose was often given humorous, erotic treatment by Japanese artists and craftsmen. A *konoha tengu* also has a pair of feathered wings behind his shoulders, just like angels' wings but a little smaller. *Konoha* literally means "the leaves of trees"; in the mountains this type of *tengu* wears only a garment of leaves. When appearing among humans, however, he wears the military costume,

pillbox cap, and sword of a *yamabushi* (warrior monk).

The other type of *tengu* is called *karasu tengu* (literally, "crow *tengu*"). He has a somewhat more birdlike body and his face terminates in a huge beak.

Folk dance masks like this one are far less refined than the masks worn in Nō, the classic, courtly theater of Japan. Good folk masks are broad, powerful pieces of sculpture, meant to be seen in motion. These masks were used for open-air folk dance-dramas in rural villages, or worn in the processions that marked numerous country festivals each year.

17. Karashishi (Mythical Lion)

Roof tile, gray pottery
H. 18½", L. 23"
Edo Period, 19th century
Gift of Dr. Fred S. Hurst 82.223.20

The Buddhist lion was the defender of the Law (the teaching of the Buddha), so sculptures of him stood guard over the Buddha's throne, sacred buildings, and temple precincts. As the lion gradually became secularized in China (see cat. 15), his statue became a protector of palaces, mansions, and tombs, as well as temples. It is in this protective capacity that we see him here on a Japanese roof tile. Since early times, the roofs of important buildings in China were provided with rows of Taoist spirit-animals as guardians of the building. They were rendered as three-dimensional ceramic sculptures, often glazed, each one integral with one of the outermost tiles along the four radiating diagonal ridges formed by the intersection of the eaves at the four corners of the building.

Early Japanese roofs were thatched with miscanthus (a type of reed) stalks or shingled with cypress bark. Chinese-style tile roofs were introduced from Korea along with Buddhism. Japanese tile roofs often incorporate oni-gawara (demon tiles) at ridge ends; these ferocious monster-masks serve the same protective function as the guardian spirit-animals on Chinese roofs: they frighten away evil spirits. Karashishi tiles like the present one are less common, but they involve the same kind of protective symbolism.

In spite of his function as a guardian, this karashishi is shown in his playful aspect, sporting with a peony, his favorite flower. But the peony, too, has auspicious implications for the occupants of the building on which the tile stands.

The tree peony (botan) is a great favorite in the gardens of north China, Korea, and Japan. Its large, showy blossoms appear in May, when the weather is at its best. The peony is one of the traditional flowers of the four seasons: Spring, peony; Summer, lotus; Fall, chrysanthemum; Winter, plum blossom. A mythical lion gamboling among peonies may seem to be merely a playful motif, but in fact it carries significant symbolism as well. The lion is an emblem of energy and valor, while the peony is a symbol of regal, worldly power. A peony plant bearing abundant, radiant flowers and leaves is an omen of good fortune. Conversely, one with wilted blossoms and falling leaves is a portent of poverty or impending disaster. Needless to say, depictions of peonies in Far Eastern art always show the flowers and leaves in their most abundant and perfect state, as we see here.

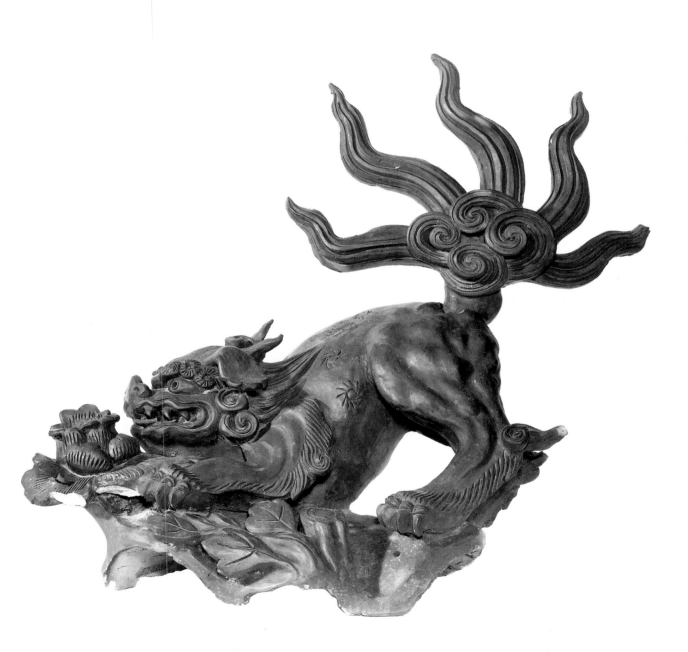

18. Ox
Polychromed gray pottery
H. 9¼", L. 20½"
Edo-Meiji Period, 19th century
Gift of Dr. Harvey Lederman 84.194.3

Sugawara Michizane (845–903; see cat. 2, 12) became a prominent minister at the imperial court in Kyoto. In those days, bullocks were used to pull the court carriages of the Kyoto nobility. Noblemen vied with each other in obtaining the sleekest, strongest, fastest bulls. Even bullock races were held, although a court carriage normally proceeded at a slow, stately pace, with a groom walking beside the ox and holding the animal's bridle.

Like other Kyoto noblemen, Michizane was proud and fond of the splendid bullocks he owned. It will be remembered that Michizane's enemies plotted against him and caused him to be unjustly banished to far-off Kyūshū, where he died of a broken heart after two years in exile. While his ashes were being transported to a cemetery for burial, the bullock pulling the carriage mysteriously stopped and lay down. Grooms were completely unable to budge the stubborn animal, so the court attendants dug a grave on the spot and buried Michizane's ashes there. A Shintō shrine was subsequently built there to honor Michizane and mark the site.

Michizane's avenging spirit wreaked havoc on Kyoto, assuming the form of the Thunder God and repeatedly striking the Imperial Palace with lightning, among other things. In order to placate his spirit, the emperor restored Michizane's former honors and deified him as Tenjin, the Shintō god who came to be regarded as the patron of literature.

In 836, nine years before Michizane's birth, a Shintō shrine was erected at Kitano, just northwest of Kyoto. In 947 another, much larger shrine, the Kitano Temman-gu, was built at Kitano and dedicated to Tenjin, the deified Sugawara Michizane. Subsequently, numerous branch shrines of the Tenjin cult were built in other parts of Japan as well.

Each major Tenjin shrine displays a large stone or bronze sculpture of a recumbent ox in the shrine precinct. This bull is sacred to Michizane, in reference to the one that lay down to mark the site for his grave. A small, subsidiary Tenjin shrine, or a Tenjin shrine in a rural village, would have been equipped with a smaller pottery ox, as we see here. Formed in slab molds, with details hand-modeled and incised, this hollow pottery ox was originally covered with a layer of gesso and painted in bright colors, most of which have weathered away.

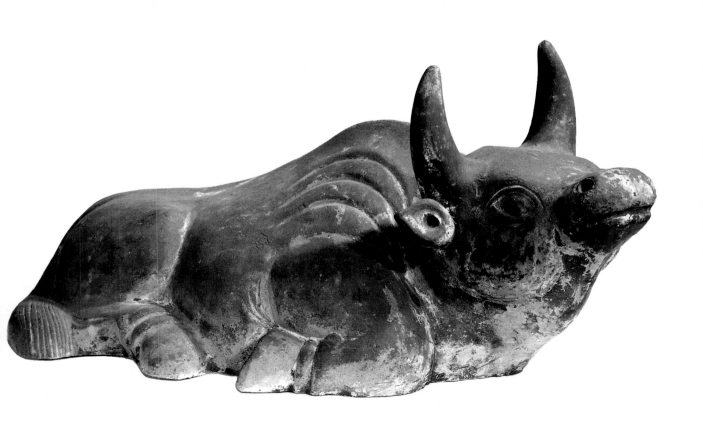

19. Pair of Foxes

Polychromed gray pottery
H. 6¼", W. 2¾" each
Meiji Period, 19th century
Gift of Dr. Kenneth Rosenbaum 84.266.5 & .6

These two alert-looking foxes once stood on the open shrine shelf (*kamidana*) high on the wall in the kitchen of some old Japanese house, as attested by the deposit of wood and charcoal cooking smoke on their surfaces. Foxes (*kitsune*) have always been credited with magic powers in Japan; there is a large body of folklore relating to them. When Japanese foxes appear as a seated pair like this, one with a scroll in its mouth, the other with a jewel, they are the messengers of Inari, the Shintō Goddess of Rice.

The two *kanji* (ideographs) forming Inari's name literally mean "Load of Rice." Rice being the staple of the Japanese diet, Inari is one of the most important Shintō deities. There are countless Inari shrines all over Japan. A pair of life-size stone foxes sit at either side of the door to every Inari shrine, hence the common but incorrect Japanese belief that the fox is the God of Rice. Inari is actually the Shintō goddess Uka no Mitama no Kami (August Spirit of Food), daughter of the Sun Goddess's brother, Susano O. She is depicted as a woman with long hair holding a bowl in her right hand and standing on a fox, which is her mount as well as her messenger.

Confusion has arisen about the gender of Inari because Japanese Buddhists worship a male God of Rice having the same name. According to legend, the famous priest Kūkai (774–835, known by his posthumous title Kōbō Daishi) once met an old man at Fushimi who was carrying a sheaf of rice. Kūkai recognized the man to be a deity and proclaimed him Inari, the God of Rice. This male Inari is depicted as an old man with a beard carrying a sheaf of rice and holding a sickle, accompanied by two foxes.

The huge Inari no Yashiro at Fushimi, a short distance south of Kyoto, is the largest and most famous Inari shrine in Japan. It was founded in 711 when the goddess is said to have appeared on the hills there. Inari is worshiped as the Goddess of Rice, but also as a healer and a giver of wealth. She is also the patron of swordsmiths, owing to the legend that she assisted the famous swordsmith Munechika in forging a sword for Emperor Ichijō.

Each of these two pottery foxes was formed by pressing a sheet of clay into a concave mold to form the front half, and another sheet of clay into another mold to form the back half, then joining the two halves to produce a hollow figure. After firing, the figure was coated with gesso and painted with bright colors. The *tama* (precious jewel) on the pedestal of each fox signifies abundance and wealth.

CERAMICS

23. Shigaraki Ware Sembei Tsubo (Rice-Cracker Jar)
Stoneware with natural ash-glaze deposit
H. 13", Diam. 9"
Momoyama Period, late 16th century
Gift of Dr. & Mrs. Richard Dickes 82.219

Japanese ceramic wares are usually named after the place of production. Shigaraki is a pottery village in the mountains near Kyoto. The various Japanese ceramic wares may be grouped in six broad categories: archaeological ceramics, medieval ceramics, ceramics related to the tea ceremony, folk ceramics, porcelain, and modern ceramics. It is, of course, the fourth category, folk ceramics, that concerns us here. The Japanese are somewhat arbitrary in these classifications. For example, most medieval ceramics logically fit in the folk ceramics category. They are rough, vigorous, utilitarian wares, produced mainly by farmer-potters during the slack season of farm labor, in order to supplement their meager incomes. However, by the middle of the 16th century, tea masters were selecting some of the smaller medieval jars for use as tea-ceremony flower vases. Shortly thereafter, the tea men began commissioning these same humble potters to make pieces directly for tea-ceremony use. In this way, the medieval ceramic tradition became inexorably associated with the tea ceremony in the Japanese mind.

The Japanese limit what they call folk ceramics mainly to certain wares of the Edo Period and later. Most of this folk pottery has some form of applied decoration; most medieval wares do not. Louise Cort, the ceramics specialist at the Freer Gallery, defines Japanese folk ceramics as ware *not* made at the official kilns operated by the *daimyō* (feudal lords) in their various fiefs. And, of course, these folk ceramics were made for everyday use by ordinary people.

In terms of technique and style, the present Shigaraki Ware Jar is a continuation of the medieval storage jar tradition. It is included here as folk pottery because of its plebeian use, that of a container for *sembei* (rice-flour crackers flavored with soy sauce, the "popcorn" of Japan). The classic Shigaraki Ware storage jars of the medieval period, whether *tane tsubo* (seed jars) or *cha tsubo* (tea jars), had an ovoid profile rather than the rectangular *sembei tsubo* profile we see here. These jars were all built by the coil-and-throw process: the potter started with a disc of clay, added clay coils to form the sides, then threw the neck and lip from the uppermost coil of clay.

Like its medieval counterparts, this jar has no applied glaze. The draft in the kiln carried wood ash from the fire against the shoulder and one side of the body, building up a deposit of natural (accidental) ash glaze created by the silica in the wood ash. The cool, watery green of this ash-glaze deposit provides a perfect complement to the orange-brown clay surface around it. The surface of the gray clay burned this color during oxidation firing (with an abundance of oxygen present in the kiln). Tiny "doughnuts" of fused feldspar dot the clay surface, from feldspar pebbles present in the coarse Shigaraki clay.

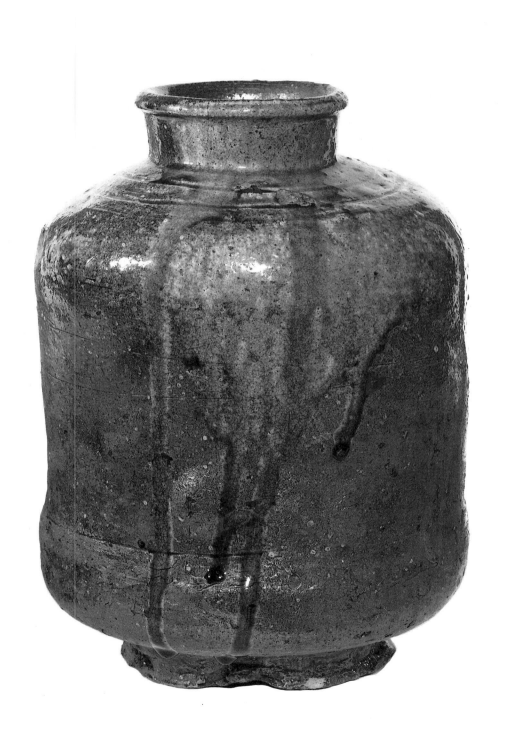

24. Yumino Ware Konebachi (Kneading Bowl)

Glazed stoneware with slip and painted decoration
H. 6⅜", Diam. 19⅞"
Edo Period, 18th century
Gift of the Tokyo Marine & Fire Insurance Co. 75.124

The output of the Yumino kiln consisted mainly of wine bottles (*tokkuri*), water basins (*mizubachi*), and kneading bowls (*konebachi*). The bottles and basins were decorated with a stylized pine tree on the front and an abbreviated mountain on the back. The kneading bowls were decorated on the inside with one or the other of these same motifs, either a pine tree or a landscape like this, a mountain peak with trees growing on the slopes and a lake below. The spontaneous boldness of these painted designs makes Yumino Ware one of the most striking and appealing of all folk ceramics.

This ware was made at the Yumino kiln, south of Takeo, in Hizen Province (modern Saga Prefecture), northern Kyūshū. Yumino Ware belongs to the Takeo-garatsu ceramic tradition; it is sometimes called Takeo-garatsu Ware. Until recently, Yumino Ware was often mistakenly called Futagawa Ware, due to confusion with a later ware made at Futagawa in nearby Fukuoka Prefecture in imitation of Yumino Ware.

By the middle of the 16th century, a few Korean potters had already migrated to Japan and settled near Karatsu City in Hizen Province. Then in 1592 and 1597, Kyūshū *daimyō* (feudal lords) participating in military dictator Toyotomi Hideyoshi's invasions of Korea kidnapped whole villages of Korean potters and transplanted them to the Karatsu-Arita area. This sudden, massive influx of Korean potters drastically altered the history of Japanese ceramics.

Much of the pottery from the more than two hundred Karatsu Ware kilns was for everyday use, but the most notable pieces were made for the tea ceremony. Various *daimyō* prudently cultivated a polite interest in the tea ceremony in accordance with Hideyoshi's passion for tea. Mid-16th-century tea masters had begun to select Korean peasant rice bowls for use as Japanese tea bowls, so transporting Korean potters to Japan was the next logical step.

After the discovery of porcelain clay at Arita in 1616, most of the Karatsu kilns converted to porcelain production. However, several other Karatsu kilns turned to the production of folk pottery instead. These included kilns around Takeo, not far from Arita. The ceramics made there are called Takeo-garatsu and include Yumino Ware.

A huge, shallow, conical *konebachi* like this was made to withstand rugged use in the kitchen, for kneading and mixing. Its thick, sturdy walls are well suited to this purpose. Yumino Ware is made of reddish-brown stoneware. The interior of this bowl is covered with white slip (liquid clay) applied with a broad, flat brush to leave concentric brush marks (*hakeme*). The upper half of the exterior is covered with white slip given an undulating wave pattern by combing through the wet slip with the fingers as the bowl turned slowly on a potter's wheel. The stylized mountain and lake are painted in overglaze iron brown and copper green. The entire bowl is covered with a clear glaze.

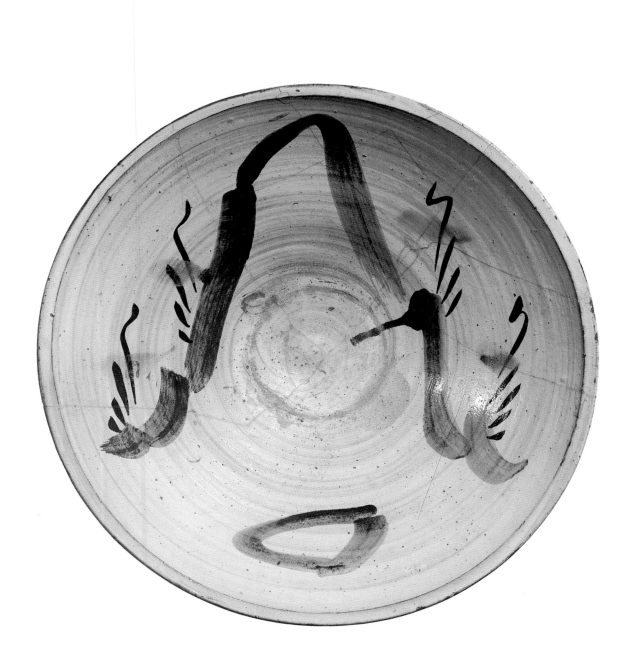

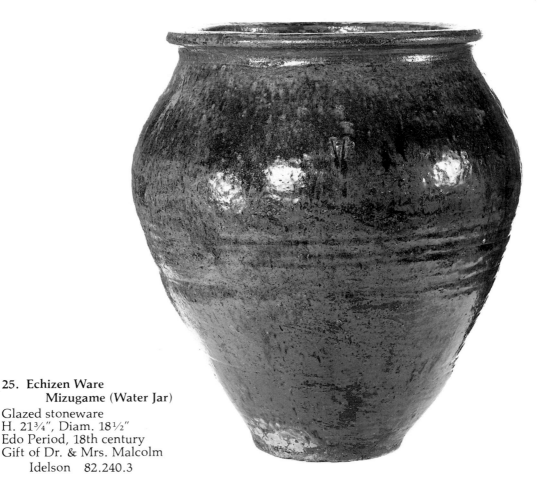

25. Echizen Ware
 Mizugame (Water Jar)
Glazed stoneware
H. 21¾", Diam. 18½"
Edo Period, 18th century
Gift of Dr. & Mrs. Malcolm
 Idelson 82.240.3

Echizen was one of the "Six Old Kilns"—that is, one of the six major ceramic traditions of medieval Japan. The kilns were located in Echizen Province (modern Fukui Prefecture), which is situated on the Japan Sea, north of Lake Biwa, in central Honshū. Like the other five kilns, Echizen produced Sue Ware before the medieval period. Sue was a Korean-style gray stoneware produced in Japan since the 5th century. Production of Echizen Ware proper began in the Fujiwara Period (897–1185) and continued into the Muromachi Period (1392–1568). Ceramic manufacturing in Echizen Province was revived during the Edo Period (1603–1868) with the production of rugged, utilitarian folk pottery, water jars like this being a specialty.

In Japan, large ovoid jars with wide mouths are usually *mizugame* (water storage jars). One or more huge *mizugame* used to stand next to nearly every house as a source of water to fight fires. Fires were especially frequent in old Japan. Houses were made of wood, paper, and straw; light was provided by candles and oil lamps. Earthquakes were often the immediate cause.

Since it was impractical to throw a pot this large, these big jars were coil-built. Much of the other Edo Period Echizen Ware is covered with the same type of mottled brown/tan/olive ash glaze we see here. This jar bears an impressed kiln mark, the *katakana* (syllabary character) *sa*. The potters at the *sa* kiln must have been very proud of their work. Several other surviving jars have the *sa* mark displayed prominently on the shoulder, as here, rather than at the foot of the jar, where Japanese potter's marks are usually placed.

26. Echizen Ware Suiteki (water-dropper)

Glazed stoneware
H. 2⅞", W. 2⅛"
Edo Period, 18th century
Lent by Dr. Kenneth Rosenbaum TL1984.180

This utterly charming figure of a seated monkey is included here in the section on ceramics rather than in the previous section on sculpture because it functioned as a water container. A *suiteki* is a small pouring vessel used in preparing the water-and-ink mixture for writing and painting. A tiny pool of water is dribbled onto the concave portion of a slate ink-stone. An ink-stick is dipped into the water and ground on the stone until the right amount of ink has mixed with the water. An ink-stick is a cake of ink consisting of pine soot mixed with animal glue. Once the ink-water mixture has dried on the surface of the paper, it is no longer water soluble.

A *suiteki* was an indispensable item on every writer's desk. Usually made of either bronze or porcelain, *suiteki* often took fanciful forms, but seldom with as much personality as this monkey, who appears to be sitting down at some party, singing a song. He is pinch-formed (hand-modeled) of dark stoneware clay covered with the same kind of olive-brown ash glaze as the Echizen Water Jar (see cat. 25).

27. Yatsushiro Ware Chatsubo (Tea Storage Jar) from the Kōda Kiln

Glazed stoneware with slip inlay
H. 16½", Diam. 12⅝"
Edo Period, 18th century
Gift of Carll H. de Silver 02.32

This jar is a splendid example of ceramic art at its best. The jar's shape, its proportions, the way the decoration fits and enhances its form, the striking contrast between the gray clay and the ivory-white slip, the rich visual texture of its surface, the luxuriousness of the clear glaze, all these elements work together in perfect harmony to make this jar a masterpiece.

During and shortly after Hideyoshi's invasions of Korea in 1592 and 1597, many Korean potters were brought to Japan. These transplanted Korean potters founded six major new Japanese ceramic traditions: Karatsu (see cat. 24), Satsuma, Takatori, Agano, Yatsushiro, and Hagi. All but the last of these groups of kilns were located on Kyūshū. Hagi Ware was made at the town of Hagi in Nagato Province (modern Yamaguchi Prefecture) near the western tip of Honshū. Kyūshū and Yamaguchi Prefecture are the part of Japan closest to Korea, separated from the southern tip of the Korean peninsula by the Straits of Tsushima, 110 miles wide.

Yatsushiro was the main town of Higo Province (modern Kumamoto Prefecture) in central Kyūshū.

The Kōda Kiln was just outside the town of Yatsushiro. The shape of this jar is based closely on that of a Korean porcelain jar of the 17th century. The technique of slip-inlay decoration became a specialty of Korean potters, particularly those of the early Yi Dynasty who produced Punch'ong Ware in the 15th–16th centuries. For slip-inlay decoration, the design is first incised or stamped into the leather-hard clay. Next, white slip (liquid clay) is applied. After the slip sets, it is scraped off the main surface, leaving slip in the depressions as inlay. The Japanese call this technique, and the ware decorated with it, *mishima* because it reminded them of the minute writing in woodblock-printed calendars sold at the Mishima Shrine. This shrine was in the town of Mishima in Izu Province (modern Shizuoka Prefecture). The almanacs sold at Mishima Shrine were a *meibutsu* (famous local product) bought by travelers from all over Japan.

The neck of this jar is cracked in several places. The cracks have been filled in with gold lacquer. This is the traditional Japanese way of repairing good ceramics.

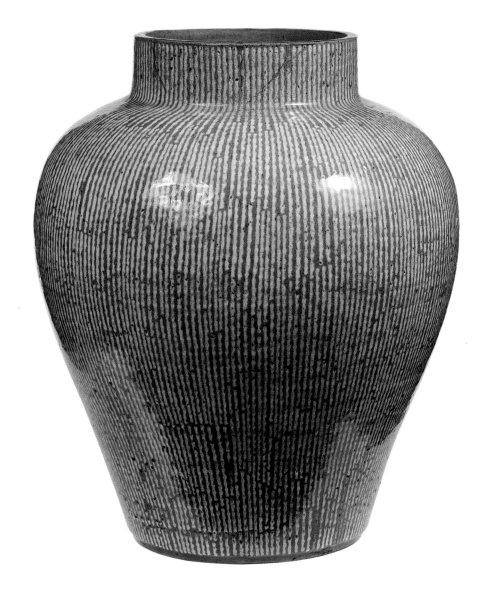

28. Tamba Ware Chatsubo (Tea Storage Jar)

Glazed stoneware
H. 14", Diam. 12"
Edo Period, 17th century
Gift of William D. Stiehm 81.205.1

Tamba was another of the "Six Old Kilns," the six major ceramic traditions of medieval Japan (see cat. 20, 21, 23, 25). The Tamba kilns were located in Tamba Province (modern Hyōgō Prefecture), not far from the present city of Kobe. Tamba Ware has been in continuous production since the Kamakura Period (1185–1334). Like the other Six Old Kilns, prior to that period Tamba produced Sue Ware, whose gray-black surface is due to reduction firing (limited oxygen in the kiln during firing). When the medieval kilns were built, utilizing improved designs, they yielded a reddish-brown surface due to oxidation firing (an abundance of oxygen in the kiln during firing).

Medieval Tamba, like all the Six Old Kilns except Seto, had no applied glazes, only natural (accidental) ash-glaze deposits and kiln gloss (see cat. 23). By the beginning of the Edo Period (1603–1868), Tamba potters had begun to use applied glazes. At that point, Tamba Ware begins to be considered folk pottery rather than just a continuation of the medieval tradition, according to the present-day Japanese classification.

In the 17th century, Tamba potters employed a particularly striking combination of glazes, as we see here. The exterior of this jar was first coated all over with *akadobe* (red-earth slip glaze), semi-matte and a rich reddish-brown color. Then the potter ladled on a glossy, slightly translucent, black ash glaze around the neck and shoulder in such a way that it ran down the sides of the jar in long drips. The contrast between the superimposed olive-black glaze and the purple-red slip, as well as the long rivulets of the black glaze, are very dramatic indeed.

This jar, like all but the smallest Japanese storage jars, was made by the coil-and-throw process. The jar is identified as a tea-storage jar by its medium size, and by the four ears (small loop handles) on the shoulder. The stopper was wood. It was sealed by covering it with a few sheets of paper and cloth, then binding them securely with a hemp cord around the neck of the jar. The ears originally assisted in securing the cord but eventually became traditional, decorative adjuncts of tea jars.

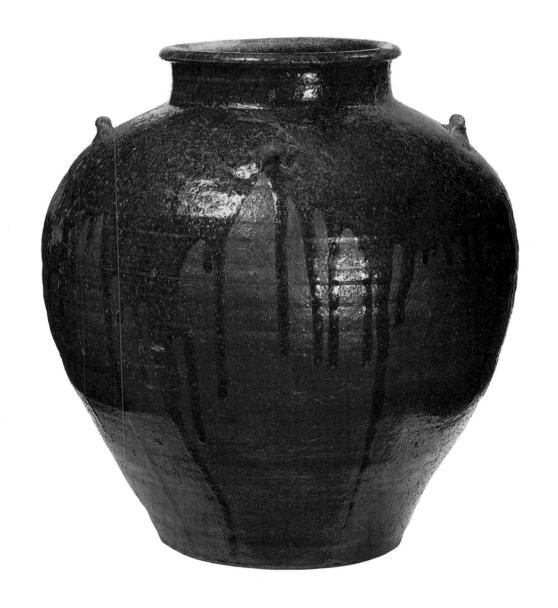

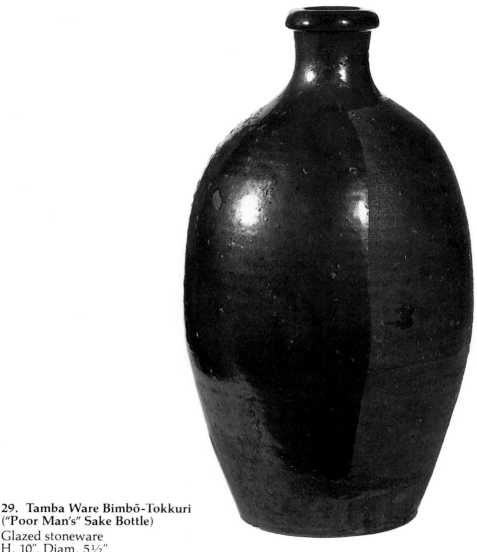

**29. Tamba Ware Bimbō-Tokkuri
("Poor Man's" Sake Bottle)**
Glazed stoneware
H. 10", Diam. 5½"
Meiji Period, 19th century
Gift of William D. Stiehm 81.205.7

It was customary during the Edo and Meiji periods for sake shops to order their own sake bottles from local potters. The name of the wine shop was often inscribed on the pottery bottles. Customers who took the sake home would return the empty bottles to the wine shop for refilling.

Bimbō-tokkuri were made at both Tamba and Shigaraki during the late Edo and throughout the Meiji period. This was the cheapest type of sake bottle: It was not ordered in advance by a wine shop with the shop's name on it, instead it was mass produced and kept in stock. The bottle was coated with a brown glaze, but a rectangular panel was left in resist (unglazed) so that the wine shop purchasing the bottle could write its own name on the unglazed panel using regular brush and ink.

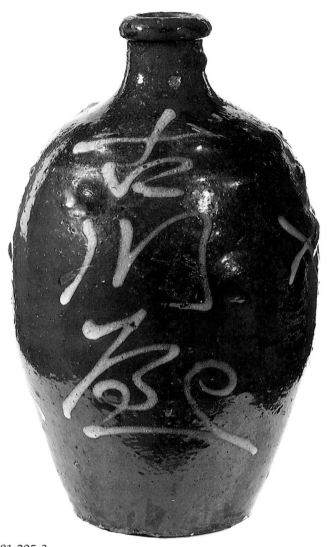

). **Tamba Ware Tokkuri
(Sake Bottle)**

lazed stoneware with
 trailed slip
. 12¾", Diam. 7"
leiji Period, 19th century
ift of William D. Stiehm 81.205.3

This is the standard type of custom-ordered Tamba
ke bottle, with the wine shop's name permanently in-
ribed on it (see cat. 29). Such a bottle was first
overed with brown glaze. Then the letters were trailed
n with white slip (liquid clay). The slip was applied
ith a tool unique to the Tamba kilns. A section of
ollow giant bamboo stalk about 1 foot long, closed at
e bottom by the joint in the stalk, acted as a reser-
oir for the slip as well as the handle of the applicator.
6- or 7-inch-long tubular spout made of regular bam-

boo was attached perpendicularly near the bottom of
the larger tube. Working quickly and deftly, the potter
trailed a raised ridge of white slip onto the glaze
surface through this bamboo spout.

The contrast between the raised, matte, white slip
and the glossy, dark-brown glaze around it is very
striking. The more skillful Tamba potters often achieved
handsome, flowing, rhythmic, vigorous calligraphy in
their sake-bottle brand names, as we see here. The
family name of this wine shop is Furukawa.

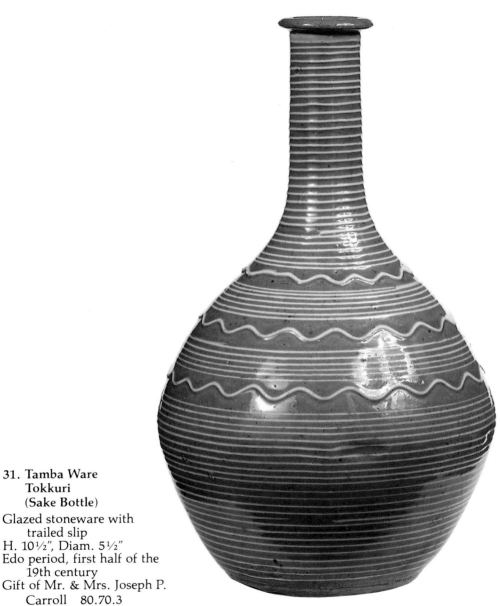

31. Tamba Ware Tokkuri (Sake Bottle)

Glazed stoneware with trailed slip
H. 10½", Diam. 5½"
Edo period, first half of the 19th century
Gift of Mr. & Mrs. Joseph P. Carroll 80.70.3

Here the unique Tamba slip-trailing technique (see cat. 30) has been used for strictly decorative purposes rather than for identification and advertising. The sheer gaiety and exuberance of this decoration are extraordinary.

For this effect, the white slip was trailed on while the bottle was turning on a potter's wheel. The slip was applied directly onto the surface of the gray clay rather than onto a brown glaze. After the slip had set, the entire piece was covered with a clear glaze and fired.

32. Seto Ware Aburazara (Oil Plate)

Glazed stoneware with iron-painted decoration
H. ⅞", Diam. 8¾"
Edo Period, early 19th century
Gift of Willard Straight 38.146

Abura means "oil" and *sara* means "plate" or "dish."
Aburazara are also called *andonzara* (lamp plates). An
andon is a lanternlike lamp-housing having a light
wood frame covered with translucent white paper. The
actual light source was a tiny oil lamp, usually a small

pottery vessel with a spoutlike wick holder. One side
of an *andon* is a hinged door. The oil lamp was placed
on a wood or metal stand high up inside the *andon*. An
aburazara was placed on the wooden base of the *andon*,
directly below the oil lamp, to catch the excess oil that
frequently dripped from it. Otherwise, the dripping oil
would be messy and might start a fire.

Andon were the standard means of lighting Japanese
interiors before the introduction of gaslight and elec-
tricity in the late 19th century. Thus a vast quantity of
aburazara were produced. Seto was the main source

for ceramic *aburazara* in the late 18th century and first half of the 19th century, but more affluent Japanese preferred bronze *aburazara*, and pottery ones were used mainly by the common people. Not many have survived; they were easily broken and not valued highly by their owners. Whether of metal or pottery, *aburazara* always have the same characteristic shape: round and flat, with a low, straight, upturned rim.

Seto was one of the "Six Old Kilns," the six major ceramic traditions of medieval Japan (see cat. 20, 21, 23, 25, 28). Whereas the other five kiln groups produced mainly rough, unglazed storage jars, the output of the Seto kilns was much more varied and sophisticated. In the Kamakura Period (1185–1334), Seto potters were already using two types of applied glazes: a light green glaze in imitation of Sung Dynasty celadon porcelain, and an iron-brown glaze in imitation of Sung brown-black-glazed stoneware (*temmoku*).

The town of Seto, in Owari Province (modern Aichi Prefecture), in central Honshū, not far from the city of Nagoya, is still one of Japan's major ceramics-producing areas today. So ubiquitous have its products been from the 13th century onward that *setomono*

(literally "Seto thing") became a common Japanese word for pottery in general. During the Edo Period (1603–1868), a wide variety of ceramic types were made at Seto, including tea-ceremony objects and even porcelain. However, some of the Seto kilns made inexpensive wares for the common people; the best of these are now classified as folk art.

The present *aburazara* is an excellent, characteristic example of Seto folk pottery. Since oil plates spent most of their time at the bottom of lamp stands, there was really no need to decorate them. Yet the Japanese love of exuberant decoration asserted itself: Most Seto *aburazara* have briskly painted designs of landscapes or flowers. The landscape on this plate is the most typical design of all. Stylized and abbreviated, it was painted thousands of times but seldom lost its spontaneous vigor. The specific subject is an idealized Chinese-style landscape in which a thatched kiosk is surrounded by trees on the shore of a lake, with a flight of wild geese passing overhead. It is painted in iron-oxide brown-back slip on a cream-colored glaze over a buff stoneware body.

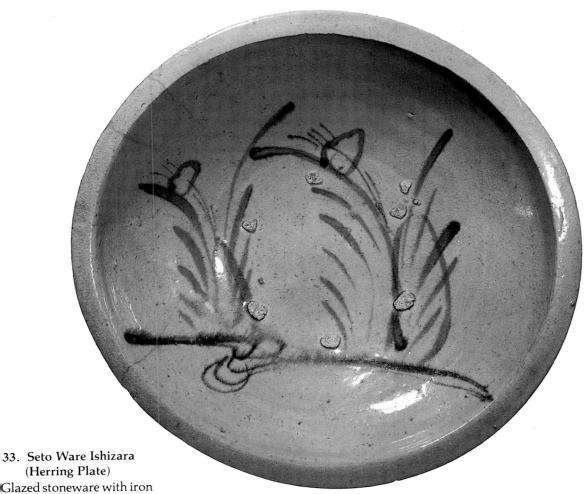

33. Seto Ware Ishizara
(Herring Plate)
Glazed stoneware with iron
and cobalt painted decoration
H. 3⅝", Diam. 14¼"
Edo Period, first half of the 19th century
Gift of Dr. Bertram Schaffner 74.108.2

Along with *aburazara, ishizara* are among the three most characteristic types of folk pottery made by the Seto kilns in the late Edo Period (see cat. 32). *Ishi* means "stone" and *sara* means "plate." The term *ishizara* perhaps therefore refers to the relative strength, thickness, and heaviness of these plates. Actually large, shallow bowls with everted rims, they were used to serve a kind of herring stew that was popular in roadside stalls of the period, hence their other name, "herring plates."

The painted decoration on *ishizara* is similar to that of *aburazara* in its laconic stylization and spontaneous vitality, but the technique was slightly different. Instead of iron slip painted over a cream-colored glaze, the design was painted in iron-oxide brown and cobalt-oxide blue under a clear glaze on the buff-colored clay. Here the motif is irises by the edge of a tiny stream. The six large spur-marks are characteristic of *ishizara*. Pellets of clay were placed between the plates when they were stacked for firing; otherwise, the glaze on one would fuse it to the one above during firing.

34. Seto Ware Uma-No-Me Zara (Horse-Eye Plate)
Glazed stoneware with iron-painted decoration
H. 2", Diam. 10⅛"
Edo Period, first half of the 19th century
Gift of Willard Straight 38.149

Ishizara, aburazara, and *uma-no-me zara* are the three most characteristic types of folk pottery produced by the Seto kilns in the late Edo Period (see cat. 32, 33). *Uma-no-me* means "horse-eye" in the sense of

"bull's-eye," a concentric-circle design, except that the horse-eye motif is elongated (oval-shaped) as we see here. The Japanese call a true bull's-eye design *ja-no-me* (snake-eye).

Depending on the size of the plate, five or six horse-eyes form a continuous border around the undecorated central portion of an *uma-no-me zara.* These plates are very fresh, free, powerful, and contemporary in feeling.

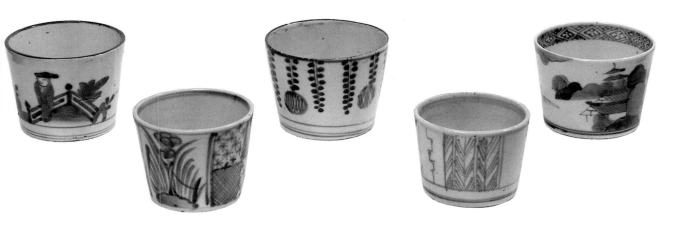

**35. Group of Five Imari Ware Soba Chōkō
(Buckwheat-Noodle Sauce Cups)**
Blue-and-white porcelain
H. 2⅛″–2½″ each, Diam. 2⅞″–3¼″ each
Edo Period, 18th–early 19th century
Gift of Dr. Henry Fischer 82.175.2,.4,.8,.9,.10

In the summertime, the Japanese like to eat *zaru-soba*, cold buckwheat noodles. The noodles are served dry, on a split-bamboo tray. With them comes a small cup of cold broth into which one dips each mouthful of noodles before eating. The broth is made of bonito stock flavored with soy sauce and ginger. One adds *wasabi* (hot green horseradish) to taste. During the Edo Period, the sauce was served in porcelain cups like these. The cups were always made in sets of five having the same design. Here we show one each from five different sets to give an idea of the range of designs. From the left: Chinese Scholar in a Garden; Irises; Wisteria; Hawk Feathers; Landscape with Cottages and Pagoda.

Porcelain is generally the antithesis of folk pottery, since it is usually refined, delicate, ornamental, and relatively expensive. However, from the beginning, some Japanese porcelain was made for everyday use by the common people. *Soba chōkō* are characteristic examples of this category.

The manufacture of porcelain began very late in Japan. The Chinese achieved porcelain by the 4th–5th century and taught it to the Koreans by the 10th century. The late-16th-century Karatsu kilns in Kyūshū were capable of firing up to porcelain temperatures, but no source of porcelain clay had as yet been found in Japan. Finally in 1616, Ri Sambei, a naturalized Korean, discovered a large deposit of good, white porcelain clay at Izumiyama near the town of Arita in Hizen Province (modern Saga Prefecture) in Kyūshū. Sambei established a porcelain kiln at Tengudani, near Arita. Within fifteen years, most of the many Karatsu kilns in the vicinity had converted to the production of blue-and-white porcelain. Thus Japan's porcelain industry was born. It happened at a very fortuitous time. The huge export porcelain industry of China serving the European market collapsed with the fall of the Ming Dynasty in 1644 and was largely dormant for fifty years. The Japanese took over this market, and the Dutch had a monopoly on the trade, since they were the only Europeans allowed to remain in Japan after the expulsion of foreigners in 1630. We usually call Japanese porcelain Imari, after the port town from which it was shipped to other parts of Japan, including Nagasaki, where it was loaded onto Dutch ships. The Japanese usually call it Arita, after the area where it was made.

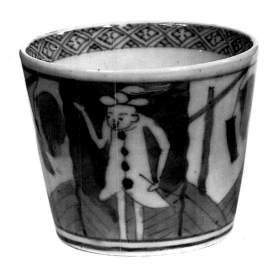
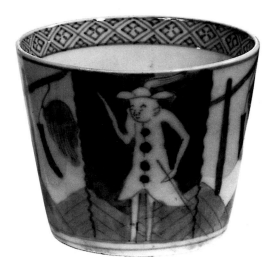

**36. Two Imari Ware Soba Chōkō
(Buckwheat-Noodle Sauce Cups)**
Blue-and-white porcelain
H. 2½", Diam. 3⅛" each
Edo Period, early 19th century
Lent by Robert S. Anderson TL1984.68.4 & .5

These sauce cups were originally two in a set of five (see cat. 35). Their decoration is extremely rare among surviving *soba chōkō*; it is a *namban* (foreign barbarian) design depicting a Dutchman and signal flags such as those used by the Dutch to send messages from their trading station on the artificial island of Deshima to their ships anchored in Nagasaki harbor.

37. Two Hasami Ware Bottles for the Dutch Trade
Blue-and-white porcelain
H. 7½", Diam. 3½" each
Edo Period, mid-19th century
Lent by Dr. Henry Fischer TL1983.297.5 & .6

Imari (Arita) was by no means the only porcelain ware made in Japan (see cat. 35, 36). Among the lesser-known ones is Hasami Ware, made at the town of Hasami in Hizen Province (modern Nagasaki Prefecture), near the city of Nagasaki.

Each of these two bottles has an inscription in Dutch written in cobalt-oxide blue under the clear glaze on the white porcelain body. One reads "Japansch Zaky" (Japanese Sake), the other "Japansch Zoya" (Japanese *Shōyu*). *Shōyu* is the Japanese word for soy sauce. The shape of these bottles, with a cylindrical body, conical shoulder, and double knop around the top of the neck, is a European rather than Japanese shape.

This pair of bottles turned up in Indonesia, where the Dutch also had an active trade, but identical examples have been excavated in Japan, principally in the Nagasaki area.

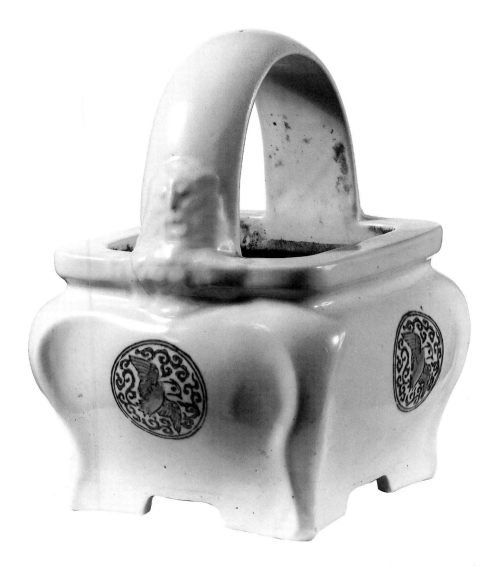

**38. Tobe Ware Te-Aburi
(Hand-Warmer, Portable Brazier)**
Blue-and-white porcelain
H. 10¼", W. 7½"
Meiji Period, 19th century
Gift of Robert S. Anderson 84.68.3

Although virtually unknown in the West, the Tobe kilns on Shikoku have been an important source of white porcelain in Japan since the late Edo Period and are still in production today. Shikoku is the large island separating the Inland Sea from the Pacific Ocean. The

Tobe kilns are in Iyo Province (modern Ehime Prefecture) near the city of Matsuyama. The white porcelain made at Tobe is usually rather heavy and utilitarian, so Tobe is classified as a folk kiln. Individual pieces of Tobe Ware are often quite handsome and imposing, like this one. The handle has a molded, applied lion mask where it attaches to the body on each side. Each of the four sides of the body has a rondel design of a flying mandarin duck and *karakusa* (Chinese-style vine scroll). In this case, the underglaze cobalt blue was stenciled on rather than hand-painted, a common practice on blue-and-white porcelain of the Meiji Period.

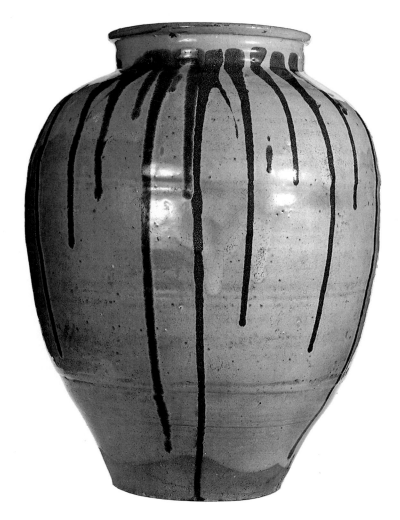

39. Shigaraki Ware Chatsubo (Tea Storage Jar)
Glazed stoneware with ladled overglaze decoration
H. 20½", Diam. 15½"
Edo Period, mid-19th century
Gift of Mr. & Mrs. Harry Kahn 80.42.1

During the Edo Period, much of the production at Shigaraki consisted of various glazed, utilitarian ceramics, the more interesting of which are now classified as folk art (see cat. 20, 23). Among the most striking are these magnificent storage jars with green and blue stripes on a white glaze.

This style of late Edo–early Meiji Shigaraki decoration is called *hagi-nagashi*. The rich, thick, semimatte white glaze, which blushes lavender in places, is like that on the famous Korean-style tea bowls made at the town of Hagi in Yamaguchi Prefecture on the southwestern tip of Honshū. Hagi Ware is one of the Japanese ceramic traditions founded by Koreans after Hideyoshi's invasions of Korea in 1592 and 1597 (see cat. 24, 27). *Nagashi* is from the verb *nagasu*, "to pour," "to flow," and here, "ladled." The potter ladled on the long rivulets of copper-green and cobalt-blue overglaze. The typical orange-buff Shigaraki clay may be seen below the edge of the glaze at the base of the jar.

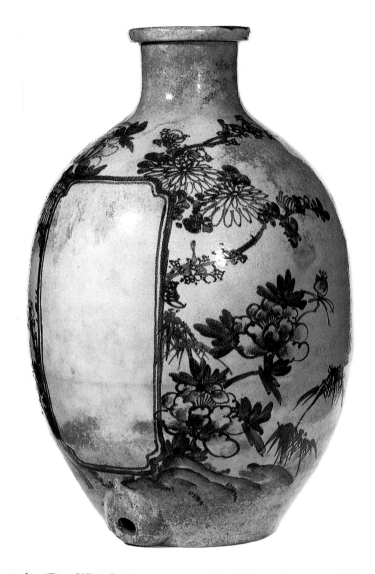

. Shigaraki Ware Sakatsubo (Rice-Wine Jar)
lazed stoneware with painted cobalt decoration
, 19¼", Diam. 11"
eiji Period, 19th century
ift of Mr. & Mrs. David Goldschild 83.184.1

Like a *bimbō-tokkuri* (poor man's sake bottle), this
lendid wine urn bears a painted panel on the front
r the insertion of a wine shop's name (see cat. 29).
therwise, this boldly and elaborately decorated vessel
quite different from the plain brown *bimbō-tokkuri*.

The hole in the front of this urn near the base is for
the insertion of a bamboo spigot for serving sake. The
entire urn is covered with "white Hagi" glaze (see cat.
39). The decoration was painted with cobalt-blue over-
glaze. It consists of three of The Flowers of the Four
Seasons: plum blossoms (winter), peonies (spring), and
chrysanthemums (fall). The summer flower, lotus, has
been omitted. Perhaps the lotus's Buddhist symbolism
was deemed inappropriate to a wine shop! Here bam-
boo has been included instead.

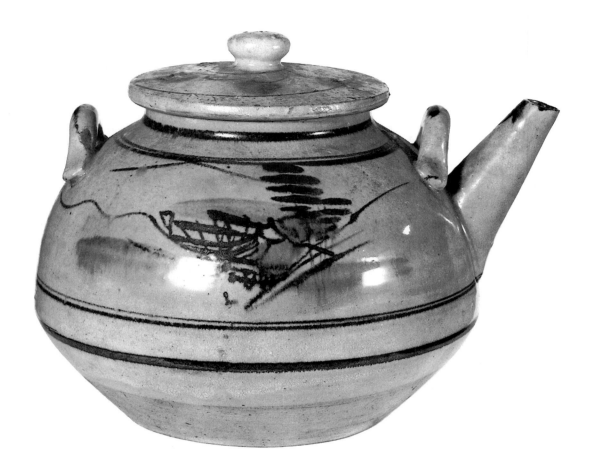

41. Shigaraki Ware Sansui Dobin (Landscape Teapot) from the Kōyama Kiln
Glazed stoneware with white slip and
painted decoration
H. 3½", L. 6¼"
Meiji Period, late 19th–early 20th century
Gift of Mr. John Lyden 83.169.12a&b

Tea was formerly brewed in iron kettles *(chagama)*; then toward the end of the Edo Period (1603–1868), the *dobin* (pottery teapot) became popular for steeping and serving tea in Japan. By the early Meiji Period (1868–1912), Shigaraki had become Japan's largest producer of pottery teapots. The distinction was short-

lived, however. In the 1930s the pottery teapot was almost entirely replaced by the aluminum teakettle that remains standard today. Ceramic teapots are most pleasing to the eye but much easier to break.

The most characteristic type of teapot from their heyday at Shigaraki is the *sansui dobin,* or landscape teapot. First the exterior of such a teapot was dipped in white slip (liquid clay), except for the base. Next an extremely abbreviated landscape design was painted on with iron-brown and copper green. It usually consisted of nearby hills, trees, and cottages with a sailboat and a mountain in the distance. Finally, the exterior of the teapot was covered with clear glaze, again leaving the buff stoneware base exposed.

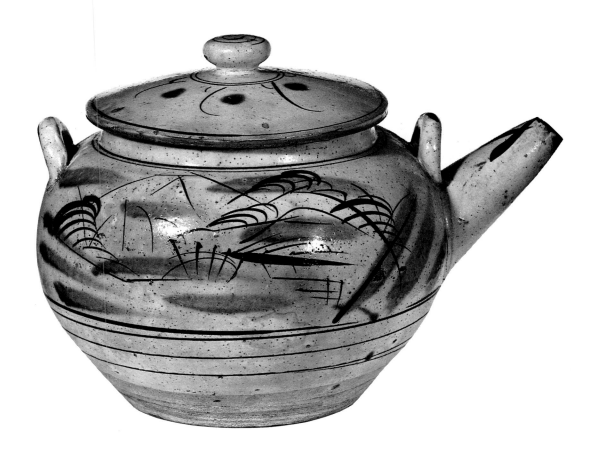

42. Mashiko Ware Sansui Dobin (Landscape Teapot)
Decoration painted by Minagawa Masu
 (1872 – after 1953)
Glazed stoneware with white slip and painted decoration
H. 6¾", L. 9½"
Taishō–Shōwa Period, c. 1915 – 35
Gift of Dr. & Mrs. John Lyden 84.139.12a&b

Mashiko is the only Japanese pottery town to have gained international recognition. This is entirely due to the fact that Hamada Shōji (1894–1977) lived there. Hamada was Japan's most famous modern potter. He settled at Mashiko in 1924 and worked there the rest of his life, except when traveling. Hamada was a close

friend of Yanagi Sōetsu (see Introduction). Together they founded the Japan Folk Art Association and its Folk Art museums. Hamada was also a dear friend of the famous English potter Bernard Leach. It was partially through Leach's writings that Hamada became the only Japanese potter known to the Western world. Hamada was also among the first group of artists and craftsmen honored with the Japanese government designation popularly called *Ningen Kokuhō* (Living National Treasure) at its inception in 1955. Pottery production was in decline at Mashiko when Hamada moved there, but his success inspired many potters to emulate him, and the town's ceramics industry has flourished ever since.

Mashiko is in Shimotsuke Province (modern Tochigi Prefecture), about a four-hour train and bus ride north of Tokyo. Potters from the town of Kasama in neighboring Hitachi Province (modern Ibaraki Prefecture) started making ceramics at Mashiko in the sixth year of the Ka-ei Era (1853). The manufacture of pottery at Kasama, in turn, had begun during the An-ei Era (1772–81) when a potter from Shigaraki was brought there. Because of the endless demand for utilitarian ceramics at Edo (modern Tokyo), Mashiko became the largest pottery production center in north-central Japan. Ceramics techniques and styles at Mashiko were borrowed from nearby Kasama, Sōma, and Aizu, as well as from far-off Shigaraki and Kyoto.

Since Kasama's pottery industry was founded by a potter from Shigaraki, and Kasama potters founded Mashiko's pottery production, it is not surprising that the present teapot is so similar to the preceding Shigaraki one (see cat. 41). However, in this case, there is an even more direct link. In 1907 an itinerant potter from Shigaraki named Kōyama Hirozō was brought to Mashiko and paid to teach the potters there how to make this kind of teapot, which thereafter became a Mashiko specialty as well as a Shigaraki one.

The abbreviated landscape on this particular teapot, like thousands of others, was painted by a woman named Minagawa Masu, who specialized in this type of teapot decoration. She was eighty-one years old in 1953 when Bernard Leach made a pen drawing of her and she recreated one of her teapot designs for him.

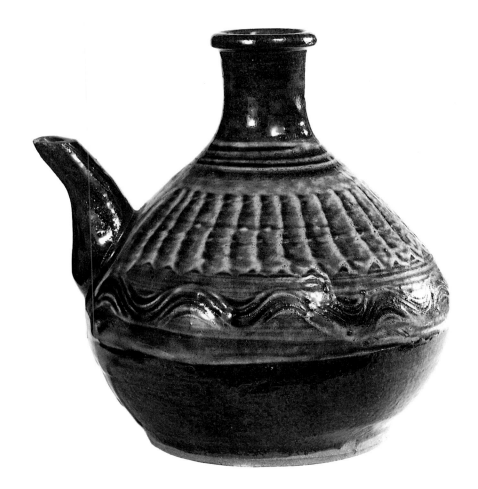

43. Onda Ware Kampin (Spouted Sake Flask)
Glazed stoneware with slip decoration
H. 7", Diam 5½"
Shōwa Period, c. 1960
Gift of Mr. & Mrs. Richard Sneider 83.173.11

Onda and Koishibara, two folk-pottery villages in northern Kyūshū, were founded by Korean potters brought to Japan during Hideyoshi's invasions of Korea in 1592 and 1597 (see cat. 24, 27). They are separated by the mountain ridge dividing two prefectures; even though close together, they are isolated from each other by the steep mountains. Onda, deep in the mountains of Ōita Prefecture, is the more remote of the two, but both villages are notable for maintaining a continu-

ous folk-pottery tradition for almost four hundred years. The technique and style of each village is so identical to the other that it is impossible to know which produced a given piece unless it bears a kiln mark. Whereas Mashiko Ware since 1924 has been mainly an unfortunately commercial imitation of Hamada Shōji's style, Onda and Koishibara have miraculously maintained their integrity until the present day, in spite of the vicissitudes of the market. They are among the only folk kilns in Japan not to have cheapened their wares by introducing modern, mass-production techniques and cute, commercial styles. Pieces made at Onda and Koishibara today are not much different from those made there a hundred or more years ago.

This traditional Japanese vessel shape is called *kampin*; it is a sake flask with a spout, used for heating and serving rice wine. The decoration on this particular *kampin* is like a compendium of Onda and Koishibara techniques. The techniques involve the use of white slip (liquid clay), a Korean speciality introduced by potters brought to Japan by Hideyoshi's troops. We have already seen *hakeme* (slip applied with a wide, flat brush, leaving horizontal brush-marks) and finger-combed slip on the Yumino Kneading Bowl (see cat. 24). Here the combing is on a much smaller scale, done with a wooden or metal comb rather than the fingers. The other technique employed here is slip-patting, which is unique to Onda and Koishibara. A *hake* (flat-edged brush) loaded with white slip is patted repeatedly against the surface of a vessel rotating slowly on the potter's wheel to produce a band of soft, parallel lines such as we see on the shoulder of this *kampin*. The white slip shows yellow through the olive-brown glaze with which this piece is covered. The buff-colored clay shows below the edge of the glaze at the base of this vessel.

Shōwa is the present era in Japan; it began with the accession of Emperor Hirohito in 1926, following his father's death, and will last until he dies and is succeeded by his son.

MINGEI: JAPANESE FOLK ART

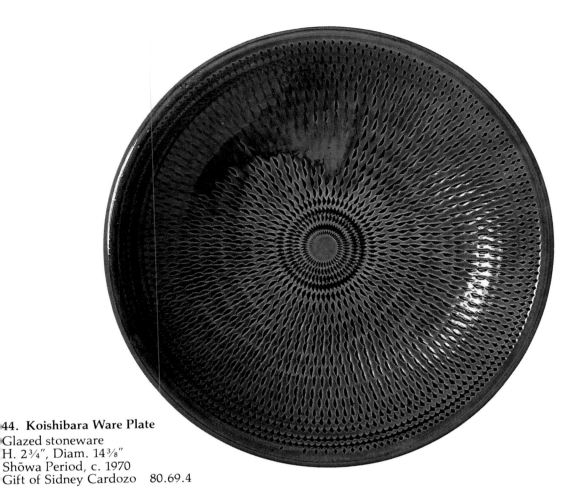

44. Koishibara Ware Plate
Glazed stoneware
H. 2¾", Diam. 14⅜"
Shōwa Period, c. 1970
Gift of Sidney Cardozo 80.69.4

Of the two northern Kyūshū folk-pottery villages founded by Koreans in the late 16th century (see cat. 43), Koishibara may have been first. It hardly matters since Onda goes back almost as far and the wares of the two villages are virtually identical. While Onda is in Ōita Prefecture, Koishibara is in neighboring Fukuoka Prefecture; the mountain ridge forming the prefectural boundary also separates the two villages. Koishibara is the more accessible today; Onda's location is quite remote.

Another interesting decorative technique employed by both villages has been used to good advantage on this platter. It is called *Kasuri-mon* (graze marks); we usually call it in English "chatter-mark decoration." It is produced with a *kanna* (the word means "plane," the carpenter's tool, but in ceramics it refers to a potter's trimming tool, like a knife with a springy blade, usu-

ally with a right-angle bend toward the tip). For *kasuri-mon*, the springlike blade is caused to chatter up and down as a leather-hard pottery vessel rotates on the potter's wheel; each time the *kanna's* tip strikes the clay surface, it makes a little nick. The nicks form a textured pattern, heightened by the glaze, which shows darker where it pools deep in each small depression. The technique can be used in conjunction with slip also, the tip of the *kanna* cutting through the slip coating to the darker clay underneath at every stroke. *Kasuri-mon* decoration is said to have been invented in China during the Sung Dynasty (960–1279), but in fact one only sees it on the wares of Onda and Koishibara, or their imitations.

The present plate bears an impressed kiln mark on the bottom: Koishibara-yaki (Koishibara Ware).

FURNITURE AND UTENSILS

45. Tansu (Chest of Drawers) Made at Sado Island
Kiri (paulownia) with iron hardware
H. 40½", W. 41"
Meiji Period, late 19th–early 20th century
Gift of Dr. Ralph Marcove 84.198.3a&b

Chests like this, with large, decorative, openwork iron fittings filling up much of the front surface, were a specialty of Sado Island, also famous for its granite sculpture (see cat. 8, 9, 10). The present *tansu* is a stacking, two-section clothing-storage chest. The two sections are nearly identical, and each has two full-width drawers. Rectangular iron loops at either end of each section swing up to accommodate shoulder poles so that the chest and its contents could be quickly removed from a house or *kura* (storehouse) in case of fire. When the two sections of this chest are stacked, the shoulder-pole loops at either end of the lower section engage eyelets on the ends of the upper section, locking the two sections together.

This *tansu* is made of *kiri* (paulownia) wood. Kiri is very light in color and extremely soft, almost as soft as balsa wood. It has long been popular for chests and all sorts of storage boxes in Japan, in spite of its softness, because it has the capacity to expand and contract indefinitely without cracking. Harder woods, with more picturesque grain, make more beautiful *tansu* but tend to crack easily from changes in temperature and humidity. The top, front, and sides of this chest are finished a rich, dark purple-brown using a lacquer and oil mixture. The interior wood is left bare, as usual for *tansu*.

Sado chests are justly famous for their elaborate, openwork hardware, made of hand-forged iron intentionally patinated a rich matte black. The motifs depicted by the fittings on this *tansu* are all traditional, auspicious symbols of longevity and prosperity. The four large, rectangular lock plates have openwork designs with incised details. Their subjects are (from top to bottom): flying crane amid clouds; flying crane and pine tree; flying crane with pine and bamboo; two tortoises amid waves. Cranes are the messengers and mounts of the Taoist Immortals, and therefore prime symbols of long life in China, Korea, and Japan. The pine tree stays green throughout the winter and resists harsh weather, so it, too, is a symbol of longevity. The bamboo bows before the wind but never breaks, thus symbolizing fortitude. Since giant sea turtles sometimes live for several centuries, the tortoise is likewise a sym-

bol of long life. The motifs depicted on the drawer-corner plates are all symbols of prosperity: treasure bags, keys, hats, fans, precious jewels, and Daikoku's hammer (see cat. 21).

With all the fancy hardware, fine woods, and careful finishes lavished on good *tansu*, it is quite surprising to find that these chests were not used as furniture in Japanese homes. They were intended only for the storage of expensive *kimono* and other valuables. The chests and their contents were kept in the *kura*, a fire-resistant storehouse, usually located across the garden behind the house, or, in a crowded city, sometimes at a separate location down the street. The *kura* had a tile roof, extra thick mud-plaster walls, and virtually no windows.

The fold-down iron loops for shoulder poles with which most *tansu* are equipped permitted them to be removed from the *kura* quickly if fire threatened the storehouse. The shoulder-pole loops permitted servants to transport *tansu* from the *kura* to the house at a change of season or any other time the family wished to exchange or examine the *kimono* and other goods stored in them. This was really the only time when the *tansu* were seen, but they had to make a good impression, not only for the family itself, but also for the neighbors, who might be watching while the *tansu* were being moved. The only time *tansu* were actually put on display is when they were part of a bride's trousseau.

46. Tansu (Chest of Drawers)

Lacquered *kiri* (paulownia) with iron fittings
H. 41¾", W. 38"
Late Edo-early Meiji Period, 19th century
Gift of the Estate of Elizabeth Babbott 83.177.3

This style of clothing-storage chest, with a pair of doors across the front, usually comes from the Kyoto area. Inside the hinged doors of the present *tansu* are four full-width drawers. The hardware is hand-forged iron, intentionally patinated matte black. At the top center of each end is a "U"-shaped iron loop that swings up to accept a shoulder pole so that the chest and its contents can be moved quickly in case of fire. The latch plate at the center of the pair of doors is in the form of a stylized Chinese pink in a circle (*maru ni sekichiku*), the *mon* (family crest) of the chest's original owners.

Like the preceding *tansu*, this one is made of paulownia wood. Paulownia is ideal for chests and boxes be-

cause it is less likely than harder woods to crack from humidity changes. However, as can be seen in this photograph, the winter dryness in a steam-heated American home can be too much for even paulownia wood.

The exterior of this chest is finished in *negoro* lacquer (see Introduction, page 19). This process, and the entire concept of artificially induced wear, are unique to Japan. To produce *negoro* lacquer, the primed wood surface is first coated with black lacquer and next with cinnabar-red lacquer. The red is then intentionally rubbed through to the black in places, for a delightfully mellow, worn, antique look. This technique is named for the Negoro-dera, a once powerful Buddhist temple of the Shingon Sect founded in 1130. Beginning in the Kamakura Period (1185–1334), in the late 13th century, priests of this temple used simple lacquered utensils in this style. The temple was located in Negoro village, in Kii Province (modern Wakayama Prefecture), not far from Nara. The Negoro-dera became extremely powerful in the Muromachi Period (1392–1568) but was destroyed by Toyotomi Hideyoshi in 1585 because the temple's mercenary soldier-monks were a threat to the dictator's regime. Lacquer ware in *negoro* style is still being made today. The earliest *negoro* lacquer was meant to be cinnabar red only. However, the red lacquer was applied over a priming coat of black lacquer. As trays or other lacquer utensils were wiped off with a cloth after each use over several years, the red lacquer gradually wore through to the black in places. The Japanese admired this effect so much that they began creating it intentionally in the 14th century and have done so ever since.

49. *Mizuya* **(Kitchen Cupboard) Made at Hikone**
Keyaki (zelkova), *hinoki* (Japanese cypress), and
 sugi (cryptomeria)
H. 68½" (stacked), W. 35½"
Meiji Period, late 19th century
Lent by Dr. & Mrs. George Liberman
 TL1983.225.1a&b

The word *mizuya* has several meanings: the pantry
for washing and storing utensils adjacent to a tea-
ceremony room, a storage chest for tea utensils (*cha-
dansu*), or a kitchen cupboard, as we see here. This
type of *mizuya* stood in the kitchen, or its adjoining
room, and was used for the storage of food and eating
utensils. Technically the present *mizuya* is also called a
kasane-dansu (stacked chest, or chest-on-chest), since it
lifts apart in two sections, identical except for the pair
of drawers at the bottom of the lower section.

The harmonious proportions and the articulation of
the surface with a variety of vertical and horizontal
slats make this *mizuya* especially handsome and con-
temporary in feeling. Its drawer-faces are made of
keyaki (zelkova), its frame of *hinoki* (Japanese
cypress), and its panels of *sugi* (cryptomeria). The
drawer-pulls are of hand-forged iron, while the rows of
decorative nails on the doors are of red copper
(*akagane*). The upper section has three transverse
shelves.

Mizuya were a specialty of Hikone, a principal town
of Ōmi Province (modern Shiga Prefecture), on the
shore of Lake Biwa a short distance northeast of
Kyoto.

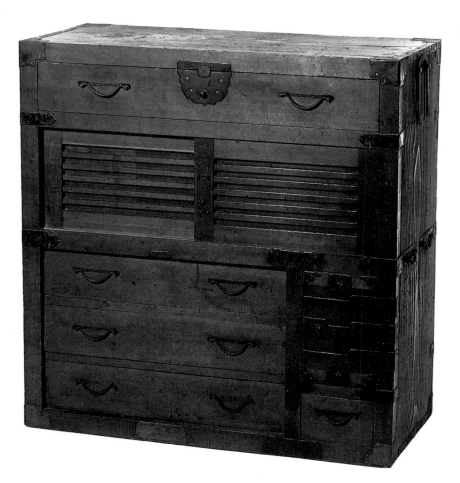

**50. Chō-dansu (Merchant's Ledger Chest)
Made at Mikuni**
Hinoki (Japanese cypress) and *sugi* (cryptomeria)
with iron fittings
H. 36¾", W. 34"
Late Edo Period, middle 19th century
Gift of Dr. Harvey Lederman 84.194.2

A *chō-dansu* is a chest of drawers for the storage of account books (*chō*) and other requisites of selling and account keeping. This type of chest stood on the *chōba*, the slightly elevated area covered in tatami (straw mats) in a retail or wholesale shop where the merchant or a chief clerk sat and conducted business. The main floor of the room was dirt, stone, or clay, so that customers coming in off the street did not have to remove their footgear on entering.

The manufacture of *chō-dansu* like this was originally a specialty of Sakai, now a suburb of Ōsaka but once a flourishing, independent port city and mercantile center. However, details of proportion and style, including the shapes of the iron fittings, differ slightly here from the almost identical merchant's chests made at Sakai. This one comes from Mikuni, a town at the mouth of the Kuzuryū River on the Japan Sea coast in Echizen Province (modern Fukui Prefecture). Mikuni became a *tansu* production center late in the Edo Period when a number of *butsudan* (household altar) makers switched to building *tansu* instead.

The frame and drawer-faces of the present chest are made of *hinoki* (Japanese cypress), while the top, sides, and drawer interiors are of *sugi* (cryptomeria). The hardware is hand-forged iron.

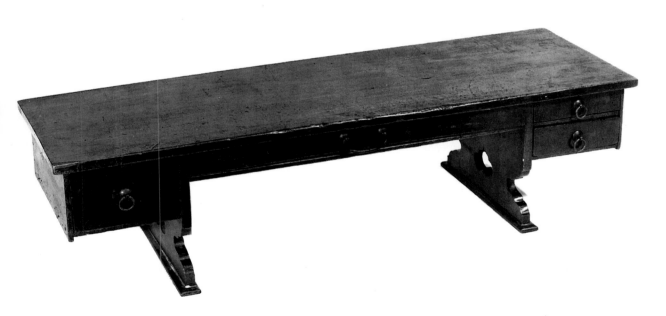

51. Chōba-Zukue (Merchant's Desk)
Hinoki (Japanese cypress)
H. 11″, W. 41¾″
Meiji Period, 19th century
Gift of Mr. & Mrs. David Goldschild 84.187.1

This is a desk (*tsukue*) used by a merchant doing business in his shop, seated on the *chōba* (raised portion of the floor; see cat. 50). As in a traditional Japanese house, the merchant sat directly on a thin cushion (*zabuton*) placed on the tatami (straw mat) floor, rather than in a chair. Thus this desk, like a traditional Japanese dining table, is quite low, for floor rather than chair sitting.

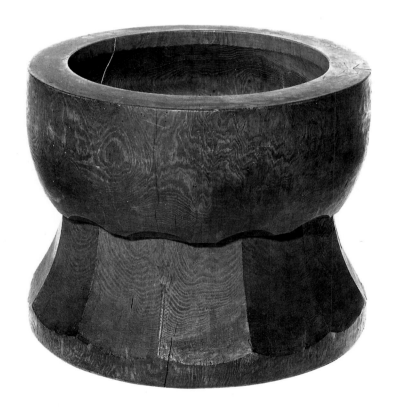

52. Usu (Mortar)
Ezo Matsu (Japanese pine)
H. 18½", Diam. 21¾"
Late Edo–early Meiji Period, 19th century
Lent by Dr. & Mrs. Malcolm Idelson TL1983.300.8

The *usu,* a large, wooden mortar or hand mill, was

ubiquitous in Japan prior to the 20th century. It was used with a *kine,* a long, heavy, polelike pestle, mainly to pound steamed rice into *mochi,* the glutinous rice-paste cake that is still a popular food in Japan today.

This old mortar has been repaired by inserting transverse, hourglass-shaped wooden wedges across the cracks to keep them from separating further.

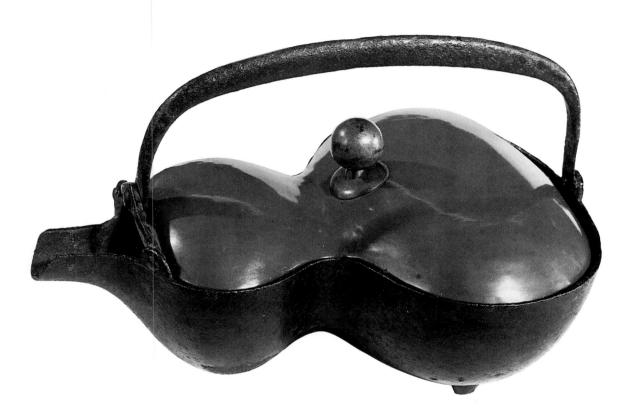

58. Chōshi (Sake Ewer)
Cast iron, lacquered wood lid
H. 4", L. 6"
Edo Period, 19th century
Lent by Robert Anderson TL1984.167.la&b

The shape of this pouring vessel is most unusual, if not unique. It represents a calabash gourd cut in half lengthwise. The red-lacquered wooden lid is shaped to suggest the other half of the gourd.

The idea is fanciful and droll because the Japanese have used calabash gourds as drinking containers since early times. A dried calabash gourd is made into a drinking gourd by simply fitting it with a stopper at the stem end and filling it with rice wine.

At the time this chōshi was used, all Japanese knew the legend of Chōkarō, who kept his magic mule in a gourd. Pouring sake from this chōsi would have reminded them of Chōkarō pouring his mule from its gourd in preparation for a journey. The mule carried Chōkarō thousands of miles but never needed fodder. Chōkarō (Chinese: Chang'Kuo) is one of the Hassennin (Chinese: Pa Hsien), The Eight Taoist Immortals. There are actually thousands of sennin (Chinese: hsien), or Taoist Immortals, but The Eight are the best known. Each of them possessed certain magic powers. Chōkarō is said to have lived in the 7th century.

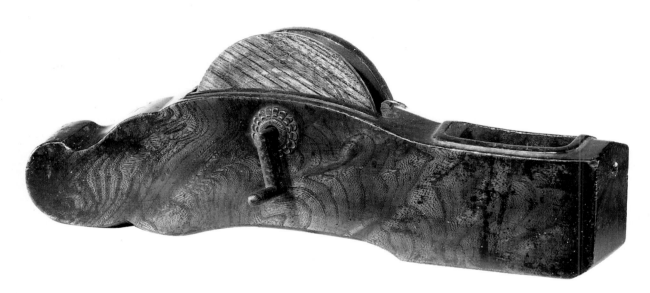

59. Sumitsubo (Ink-Line Reel)
Keyaki (zelkova) body, *hinoki* (cypress) reel, iron crank
H. 5", L. 14½"
Edo Period, 19th century
Gift of Joan Baekeland 78.83

Sumitsubo (literally, "ink jar") are the ink-line reels used by Japanese carpenters the same way our carpenters use a chalk-line (snap-line). String from the reel passes through ink-soaked flax in the recess, then out through the small hole at the end of the frame, to mark a straight line for sawing or building.

Even an ordinary tool can qualify as a work of folk art if it is sufficiently well designed and well made. The present *sumitsubo* is a splendid example, functional yet elegant, its shape meant to suggest a stylized cloud. This ink-reel must have belonged to a foreman or carpenter-architect. It is made of expensive zelkova wood with an equally expensive clear lacquer finish. The crank is hand-forged iron; its decorative bushing is shaped like a chrysanthemum made of copper and brass.

Ordinary, utilitarian baskets such as the present one are related to flower-arranging baskets only in terms of material and technique, not function. Yet these plebeian baskets are often extremely handsome. The better examples certainly qualify as folk art.

60. Basket
Split bamboo
H. 17", Diam. 18"
Late Edo–early Meiji Period, middle 19th century
Lent by Dr. Henry Fischer TL1983.297.9

This type of bail-handled, open-weave, straight-sided basket was used for picking vegetables. The present example comes from Echigo Province (modern Niigata Prefecture). The bamboo has developed a handsome, dark brown patina from over a century of use.

Basket-making has long been a significant craft in Japan. Japanese flower-arranging baskets are often impressive works of art. These, however, cannot be classified as folk art because of their refined and genteel purpose, and because of association with the tea ceremony. In Japan, flower-arranging is an art form in its own right. The completed arrangement is displayed in the *tokonoma* (decorative alcove of a formal Japanese room) as a work of art. Flower-arranging and the tea ceremony are independent but interrelated, having developed in the same rarefied milieu. A tea-ceremony room usually contains a very abbreviated flower arrangement. Practitioners of the one are usually at least conversant in the other.

61. Basket
Split bamboo
H. 7¾", Diam. 13¼"
Late Edo–early Meiji Period, middle 19th century
Lent by Dr. Henry Fischer TL1983.297.10

This type of loosely woven basket with a raised bottom was used to hold and drain stacked food bowls after they were washed. Being a household basket rather than an agricultural one (see cat. 60), it has developed a clean, reddish-brown age-patina rather than a blackish one.

62. Janome (Umbrella)

Bamboo handle, split-bamboo frame, oiled paper
L. 30¾", Diam. 45"
Meiji Period, c. 1900
Gift of Dr. & Mrs. Charles Perera 84.141.14

Among the picturesque artifacts of Old Japan, none is more familiar nor more appealing than the traditional Japanese paper umbrella. As practical as it is handsome, the Japanese umbrella (*wa-gasa*) is a marvel of ingenuity and craftsmanship. Japanese inns still provide them for their guests when it rains, and a few are sold as tourist souvenirs, but otherwise they have largely disappeared. They require a great deal of skilled handwork; the high cost of labor in Japan today makes this unfeasible when Western-style cloth-covered, metal-framed umbrellas can be turned out by the tens of thousands using machinery. Ironically, in the Meiji Period, when this paper umbrella was made, Western-style umbrellas were scarce, expensive, and fashionable. Now the situation is reversed. Western-style umbrellas were called *kōmori-gasa* (bat umbrellas) because their black cloth and metal-rib construction reminded the Japanese of bats' wings.

There are two basic types of Japanese paper umbrella.

The *bangasa* ("number umbrella" because it had a shop name and address on it, as those used at inns still do) was cheaper, with a rustic bamboo handle and natural (yellowish) color oiled paper. *Janome* were more expensive and used only by women. They were large in diameter, to keep an entire kimono dry. The bamboo handle was wrapped with rattan. The paper was dyed dark blue, brown, or black, leaving a circular band of the natural yellowish white, hence the name *janome* meaning "snake's-eye," the Japanese equivalent of our "bull's-eye" design.

Paper umbrellas used to be made all over Japan. The only craftsmen still producing them today live in Gifu City, near Nagoya, because the neighboring Mino area is still a source of good handmade paper. The split-bamboo ribs of these paper umbrellas are hinged on cotton string. The number of ribs varies; our example has forty.

63. Kamban (Shop Sign)
Hinoki (Japanese cypress)
H. 34½", W. 12¼"
Meiji Period, 19th century
Gift of Dr. Harvey Lederman 84.194.1

Traditional Japanese shop signs seem rather sedate compared to the gaudy, illuminated plastic or neon ones that accost the pedestrian on any commercial street in Japan today. The more interesting traditional signboards (*kamban*) are often ingenious in their imagery and design. This combined with skilled craftsmanship qualifies the better ones as folk art. A *kamban* is usually a rectangular wooden plank with one or two iron suspension loops at the top. If mounted parallel on the front of the building, it was painted on one side only; if hung from an inverted "L"-shaped frame perpendicular to the façade, it was painted on both sides to be seen by passersby walking in either direction.

The present *kamban* is especially admirable for the economy of means with which it so unmistakably makes its point: a shop that sells traditional Japanese candles. The two large ideograms above read: "Seiken," the name of the candle store.

LACQUER

64. Pair of Sakadaru (Sake Casks)
Red and black lacquer on wood
H. 15¾", L. 16⅛" each
Edo Period, 19th century
Lent by Dr. & Mrs. George Liberman
 TL1983.225.2&.3

This style of rice-wine container, rectangular lacquered wood with inset ends, is called *sodedaru* (sleeve cask) because its shape reminded the Japanese of a kimono sleeve. *Sodedaru* were originally made for ceremonial use (at court or Shintō shrines) and for the higher classes. By the late Edo and Meiji periods they were being made in quantity for the use of farmers and merchants in the Shōnai area. The city of Shōnai is now called Tsuruoka. It is located in Uzen Province (modern Yamagata Prefecture) on the northwest coast of Honshū. Shōnai was a center for the production of

elaborate *tansu* (chests of drawers). The same *tansu* makers made the wood bodies for these *sodedaru*.

Lacquer is made from the sap of the Oriental sumac tree. It is refined by evaporating off excess water. Poisonous (a rash breaks out if it contacts the skin) and messy to work with (it will not dry in a dry environment but requires a very humid "wet room" for that purpose), once dry, lacquer is impervious to all liquid including alcohol and all types of modern solvents. Lacquer may be used in its refined, natural state for a clear finish (see cat. 47) or else with coloring agents added for an opaque, colored finish. The most elaborate kind of lacquer is *maki-e*, with gold dust or gold flecks added to the lacquer. *Maki-e* was expensive and usually minutely ornate, the antithesis of folk art. However, rugged lacquer utensils for the common people, such as these *sodedaru*, definitely qualify as folk art.

77. Okame (The Goddess of Mirth)
Painted papier-mâché mask
H. 7½", W. 5½"
Meiji Period, 19th century
Gift of Dr. & Mrs. John Lyden 84.139.15

Okame is one of the most delightful characters in all of Japan's folklore. Her plump, jolly face always wears a happy, laughing smile. As Uzume, her more formal name, she was the Shintō goddess whose bawdy dance brought Amaterasu, the Sun Goddess, out of the cave where she was hiding and restored light to the world

(see cat. 5). When Amaterasu's grandson, Ninigi no Mikoto, descended to earth in order to found the Japanese nation, Saruta Hiko no Mikoto (Kōshin) first offered to act as his guide, then became angry and tried to block the way. Uzume again saved the day. She seduced Saruta no Mikoto with her ample charms and led him away. (Saruta no Mikoto is the God of Roads; The Three Monkeys are his attendants; see cat. 13.) Okame is also called "Otafuku"; this slightly vulgar term is sometimes applied to a plump, lascivious woman. *Otafuku-kaze* is the popular Japanese word for "mumps," in reference to Okame's plump cheeks.

Papier-mâché masks like this were worn in local village folk dance performances, often of a humorous nature. Such masks were originally produced as a cottage industry during the slack season of farm labor. Some masks and dolls were made professionally by low-ranking samurai who lost their jobs as retainers with the abolition of feudalism at the time of the Meiji Restoration. Four papier-mâché mask traditions are especially well known: the Saga masks of Kyoto, the masks from Himeji in Hyōgo Prefecture, Kurashiki in Okayama Prefecture, and the Hakata masks of Fukuoka City, Kyūshū.

MINGEI: JAPANESE FOLK ART

TEXTILES

78. Futon-Gawa (Quilt Cover)
Dyed cotton
H. 65", W. 53"
Meiji Period, 19th century
Purchase 77.10

Futon is Japanese bedding. It is rolled up and put away in a cupboard during the day, then spread out directly on the tatami floor at night. It consists of two parts: the *shiki-buton* is a narrow, thin mattress; the *kake-buton*, stuffed with cotton wadding, covers the sleeper like an American comforter. A *futon-gawa* formed the upper (outer) surface of a *kake-buton*. Late Edo and Meiji Period *futon-gawa* were often decorated with big, bold, brightly colored pictorial designs. Since most *futon* thus decorated were made to order for brides' trousseaux, the designs tend to be auspicious, incorporating well-known symbols of long life, good luck, and prosperity.

Cotton (*momen*) has been cultivated in Japan since the 15th century. The plant is semitropical and poorly suited to the Japanese climate, yet demand for cotton cloth caused it to be grown nearly everywhere in Japan except northern Honshū and Hokkaidō. Cotton cloth is warmer and softer than cloth made of *asa* (the generic Japanese term for hemp, ramie, jute, or linen, all of which are cultivated in Japan). The use of cotton cloth has been widespread in Japan since the middle of the Edo Period. Tokugawa sumptuary laws prohibited the use of silk by commoners. Wool was not used much until the Meiji Period (1868–1912); efforts to raise sheep in Japan during the Edo Period (1615–1868) were unsuccessful.

Most of the spinning, weaving, and sewing of folk textiles was done by the wives and daughters of farmers, fishermen, and laborers, especially during the winter, when there was little or no work in the fields.

Looms were quite small. The present quilt cover is made up of four vertical panels stitched together; each panel is the full width of the loom.

The dyeing technique employed here was standard for wedding *futon* and also for shop-curtains (*noren*; see cat. 85, 86). Drawn by hand, it was especially suitable for bold, large-scale designs. Called *tsutsu-gaki* (literally, "tube-drawing"), it is a paste-resist dyeing process in which the linear portions of the design are drawn with an applicator consisting of a paper cone having a metal tip that trails rice-paste onto the cloth. The fabric is then dyed various colors, the dominant background usually dark blue from indigo (*ai*).

The auspicious motifs on this *futon-gawa* are very characteristic ones: Pine, Plum, and Bamboo (*shōchikubai*) plus Crane and Tortoise (*tsuru* and *kame*). Pine, Plum, and Bamboo are called "The Three Friends of Winter"; pine needles and bamboo leaves remain green throughout the winter, while the plum is the first tree to blossom at the close of winter. The Pine, the Crane, and the Tortoise are ubiquitous Far Eastern symbols of longevity. Pine trees resist the harsh elements and live a long time. Cranes are the companions, messengers, and mounts of the Taoist Immortals. Giant sea turtles live as long as several centuries.

Nowhere can the consummate Japanese sense of design be seen to better advantage than in this quilt cover. The complex forms and colors of the plants, animals, and ocean waves are organized into a brilliant overall composition that virtually explodes with joyous energy.

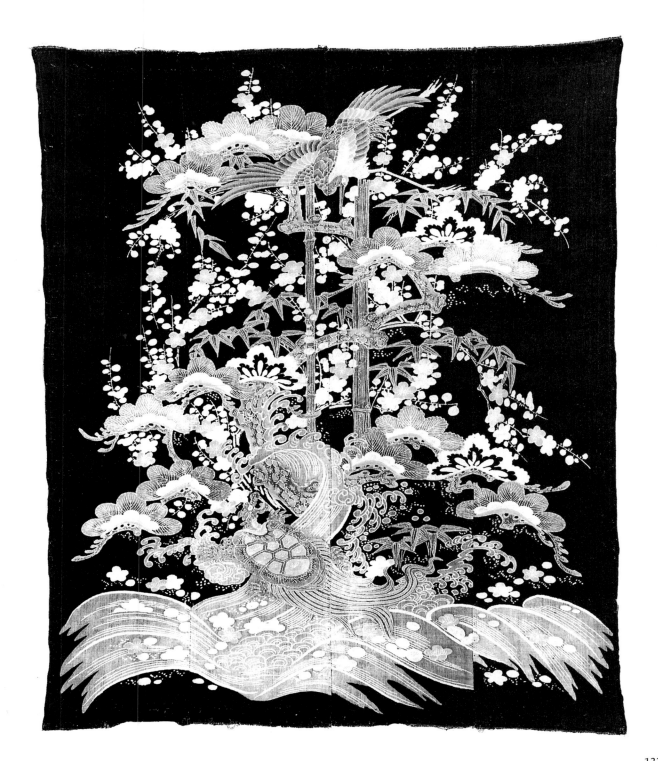

133

79. Futon-Gawa (Quilt Cover)

Dyed cotton
H. 57", W. 49½"
Meiji Period, 19th century
Gift of Eileen and Michael Cohen 82.24

Another splendid *tsutsu-gaki* wedding *futon* (see cat. 78). This time the auspicious motif is Phoenix and Paulownia (*hōō* and *kiri*). While the Far Eastern phoenix is as mythical as his Western namesake, the paulownia tree is real; we have seen its wood used frequently in Japanese furniture.

There is no connection whatsoever between the Western phoenix and the Far Eastern one. The word "phoenix" is used for want of a better translation for a large, mythical bird. The Western phoenix rises anew from his own ashes and is therefore a symbol of resurrection. The Far Eastern phoenix will dwell only in kingdoms where there is peace and prosperity, so he symbolizes those admirable qualities. The phoenix nests in the paulownia tree, so the two are usually shown together. Along with the auspicious wish for peace and prosperity, the phoenix is appropriate to a wedding because, when paired with the Dragon, it signifies the queen, with the Dragon suggesting the king, the two thus symbolizing the bride and groom.

The diagonal thrust of the phoenix's wing, and the way the paulownia bloom-stalks echo its curving tail feathers, make this quilt cover one of the most striking and appealing visual statements in the entire history of Japanese art.

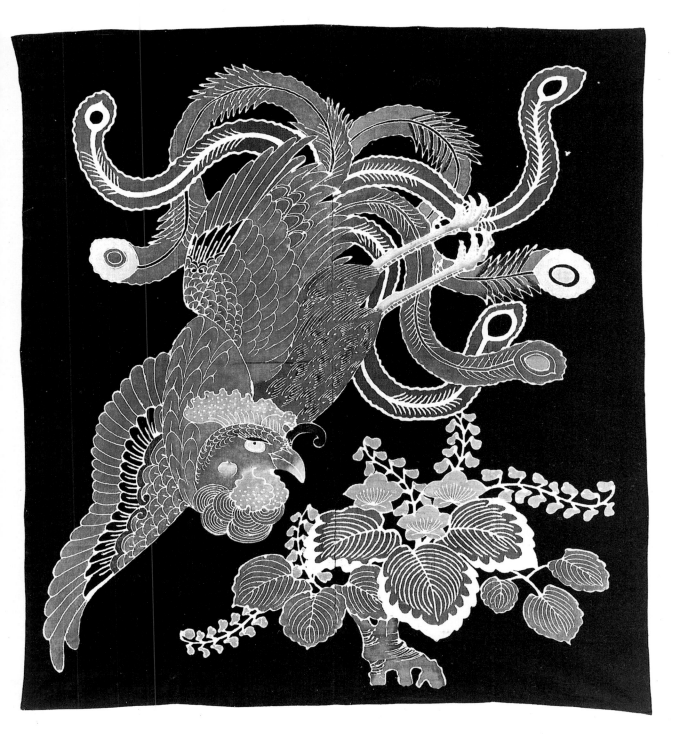

80. Yogi (Quilt in the Form of a Kimono)
Dyed cotton
H. 60", W. 61"
Meiji Period, 19th century
Purchase 84.208

A *yogi* differs from an ordinary kimono in being considerably wider, with an extra panel of material along the center of the back, and of course, in being thickly padded with cotton wadding, just like a *futon* (quilt) itself. Since it is a wrap-around garment with sleeves, the *yogi* is considerably warmer than the conventional rectangular *futon,* which is apt to allow little drafts of cold air to reach the sleeper. The present *yogi* is especially luxurious in having a satin collar.

The decoration is done in *tsutsu-gaki* hand-drawn paste-resist dyeing (see cat. 78). The design is a grape-vine with leaves and clusters of grapes. Rather surprisingly, the grape motif has no specific symbolism in the Far East, no meaning beyond the fairly literal depiction of the plant itself. The cultivation of grapes was introduced into China from South Asia, traditionally in the year 126 B.C. Since the grape was originally an import to China, Korea, and Japan, the grape motif always had a slightly exotic connotation there, evoking images of drinking grape wine in Persian gardens and that sort of thing.

83. Furoshiki (Carrying-Cloth)

Indigo-dyed cotton ikat
H. 56", W. 53"
Meiji Period, 19th century
Gift of Dr. & Mrs. John Lyden 84.139.3

Each of the four vertical panels stitched together to form this carrying-cloth is woven with white and yellow resist checkerboard designs on a dark-blue ground. The technique is double ikat (*tate-yoko-kasuri*; see cat. 82). To the Japanese, the configuration of two vertical bars crossed by two horizontal bars, such as we see in the bolder checkerboard motifs here, suggests a well crib (*igeta*), the square wooden housing at the head of a well. The four corners of this carrying-cloth are decorated with running stitches of white cotton thread in two patterns: key fret and radiating chrysanthemum petals. The swastika (*manji*) appearing in the key fret pattern here is an old Buddhist symbol suggesting the universe revolving around and returning to its center, which is God (the Cosmic Buddha). The radiating chrysanthemum petals here have a band of autumn maple leaves (*momiji*) imposed on them; chrysanthemums are the flowers of the autumn season.

Furoshiki are ubiquitous in Japan. Ladies use dainty little silk ones to carry the obligatory gift of tea cakes when visiting each other in the afternoon. Merchants use large, sturdy cotton or hemp ones to transport all manner of goods. *Furoshiki* are such a good idea that one wonders why we do not use them in America. The size and shape of objects they will accommodate is infinitely more varied than could be carried in, say, a shopping bag.

84. Furoshiki (Carrying-Cloth)
Dyed hemp
H. 68″, W. 62″
Meiji Period, 19th century
Lent by Dr. John Lyden TL1984.124.2

This is a large, sturdy, merchant's *furoshiki* made of five vertical panels of *asa. Asa* literally means "hemp," but it is also the generic term for the fibers of four plants cultivated in Japan for spinning and weaving cloth: hemp, ramie, jute, and flax. Each of the four yields thread and cloth that is coarser and stiffer than cotton, but very strong. *Asa,* along with mulberry paper, bark, and straw, was the standard material for

commoners' garments before cotton cultivation became widespread in the mid-18th century. *Asa* continued to be used well into the Meiji Period in northern Honshū and Hokkaidō, where cotton will not grow because of the cold.

The decorative technique employed here is stencil dyeing (*kata-zome*). The rice-paste resist for the white portions of the design was applied through a cut-paper stencil. The motifs are as follows: a house crest (*mon*) at the center consisting of crossed hawk feathers in a circle; a shop name at the lower left reading *kiku-ki* chrysanthemum joy); a shop crest at the upper right formed by the *katakana* (Japanese syllabary character) *ki* below a roof or mountain.

85. Noren (Shop Curtain)

Dyed cotton
H. 24", W.116"
Meiji Period, 19th century
Gift of Dr. & Mrs. John Lyden 84.139.4

This is a lively and typical example of a *noren*, the short curtain hung across the upper part of the door-way in a Japanese shop or restaurant. It was supported by a bamboo pole passed through its hanging-loops. *Noren* usually carry the business's name, or at least its house crest. The paste for the resist-dyed ideographs and crest on this particular *noren* was applied by hand with a writing brush (*fude*).

Reading from right to left in the usual fashion, one learns that this *noren* belonged to a vegetable market. It is therefore not surprising that the house-crest on the center flap shows a carrot (*ninjin*) and a giant white radish (*daikon*) crossed like a pair of swords. The in-scription reads as follows:

flap 2. kakkoku hōsanshu (abundant produce varieties from all provinces)
flap 3. oroshi-kouri (wholesale and retail)
flap 4. homba (home)
flap 5. shōhyō (trademark)
flap 6. seisen (careful preparation)
flap 7. riku-u kaidō dōri, senjū zaiho koma (the store's address)
flap 8. honten (main store) Sugawara Betsuzaemon (the shopkeeper's name)

86. Noren (Shop Curtain)
Indigo-dyed *asa* (hemp)
H. 65", W. 58"
Edo Period, 19th century
Purchase 84.209

This *noren* is composed of five vertical panels of hand-spun (*tetsumugi*) *asa* (hemp, ramie, jute, or flax) in a coarse, open weave. The five panels are joined for the top one-fourth of their length but separate below so that people could walk through the doorway where the *noren* was hung. The upper border and eight hanging-loops are of blue-dyed cotton.

The decoration is done in *tsutsu-gaki* hand-drawn paste-resist dyeing (see cat. 78). The resist design shows white on the dark-blue indigo ground. The motifs are a *mon* (family crest) consisting of a traveling hat within a circle, and a pine tree amid small bamboo.

The pine and bamboo are auspicious symbols of long life and moral recitude (the gentleman bends before adversity but never breaks, just like the bamboo before the wind).

The tradition of hanging curtains in the doorways of shops and houses goes back to the Kamakura Period. In front of a shop, the *noren* indicates the store is open for business and provides a format to advertise the shop's name; *noren* are still widely used for this purpose today. In front of a house, the *noren* provides a measure of visual privacy and protection from the sun even while the door is open.

87. Kimono
Indigo-dyed *asa* (hemp)
H. 58", W. 43"
Meiji Period, 19th century
Lent by Dr. John Lyden TL1984.174.1

This commoner's kimono is coarse and simple yet conveys a feeling of quiet dignity. It comes from Echigo Province (modern Niigata Prefecture), a cold, snowy area along the Japan Sea coast opposite Sado Island.

This overall pattern of small check designs was achieved by *katazome* (stencil-dyeing). The paste for the resist design reserved in white on the dark-blue ground was applied by means of a cut-paper stencil. The robe itself is made of *asa* (hemp, ramie, jute, or flax), while the shoulder and hip areas are lined with white cotton cloth. Cotton was scarce in northeastern Japan because the climate is too cold to grow it there.

90. Hanten (Short-Sleeved Workman's Coat)
Indigo-dyed cotton
H. 36", W. 36"
Meiji Period, 19th century
Gift of Dr. & Mrs. John Lyden 84.139.9

Quilting, called *sashiko* in Japanese, consists of stitching together two layers of cloth, with or without padding in between. Quilting is a simple needlework technique for making cloth thicker, warmer, and stronger. It has been used all over the world since very early times. *Sashiko* was produced by and for commoners everywhere in Japan. The stitching was done mainly by the wives and daughters of farmers, fishermen, and laborers. The technique was at its best in the Tōhoku District of northeastern Honshū, where the extreme cold and heavy snowfall created a need for warm clothing. The long winter months without farm labor provided free hours for the time-consuming stitchery.

The outer and inner layers of cotton cloth stitched together in crepelike crinkles to form this coat are both dyed dark indigo blue. The lapels and collar are faced with a panel of dark-blue cotton cloth having a woven pattern of vertical stripes consisting of three thin white lines each.

Although written with a different ideogram, the Japanese word for "stripes," *shima*, has the same pronunciation as the Japanese word for "island." This is because *shima-mono* (island imports), striped cloth from "The Southern Islands," i.e. Okinawa, the Philippines, and Indonesia, created a sensation among the Japanese in the 16th century. By the early 18th century, stripes had become a standard Japanese weavers' pattern and were widely used on commoners' clothing.

91. Fireman's Coat

Indigo-dyed cotton
H. 37½", W. 46½"
Meiji Period, 19th century
Gift of Dr. Kenneth Rosenbaum 84.203.1

Sashiko (quilting; see cat. 90) was used to pad the cloth of coats and hats worn by Japan's famed companies of volunteer firemen. The padded cloth helped to protect them from flames, cinders, and falling beams while fighting fires. These men took great pride in their service with the fire companies. They realized how indispensable they were, fires being so frequent in old Japan.

Some of the best *sashiko* fireman's coats have actual paintings on the inside. The present coat is displayed inside-out to show the painting. While the exterior layer of cloth was dyed the usual dark-blue, the interior layer was dyed with dilute indigo for a light bluish-gray to receive the painting colors.

The painting depicts Minamoto no Yorimitsu (called Raikō; 944–1021; see cat. 4) slaying the giant spider-demon Tsuchigumo. The fantastic exploits of this semi-legendary warrior-hero formed the subject matter for various popular tales familiar to nearly every Japanese in the Edo and early Meiji periods. Painting such a scene inside a fireman's coat suggested a parallel between Raikō's derring-do and the fireman's courage and agility.

92. Fireman's Hat
Indigo-dyed cotton
H. 23", W. 25"
Meiji Period, 19th century
Gift of Dr. & Mrs. John Lyden 84.139.7

This padded *sashiko* fireman's hat is exactly the type worn with the preceding fireman's coat. Like the coat, the hat has a painting on the inside and is displayed inside-out to show the painting.

The subject of this painting is a carp swimming rapids. In the Far East, the carp is a symbol of courage, perseverance, and success. This is the idea behind the carp banners (*koi-nobori*) flown in Japan on Boy's Day (see cat. 73). Carp symbolism derives from observed reality: carp swim upstream to spawn, just as salmon do. When the carp encounter rapids, or even waterfalls, they struggle courageously through them, leaping the falls until they either succeed or die in the attempt. In China it was said that the carp who swam all the way up the Yellow River to Lung Men (Dragon Gate) would turn into dragons there. As with the fireman's coat, the painting of the carp inside the fireman's hat is meant to suggest a parallel between the carp's courage and that of the fireman himself.

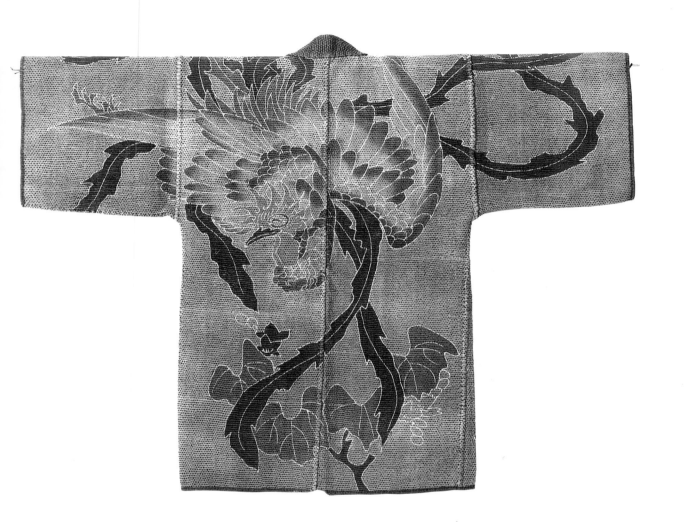

93. Fireman's Coat

Dyed cotton
H. 37", W. 46"
Meiji Period, 19th century
Purchase 83.196

This *sashiko* fireman's coat is quite similar to the preceding one (see cat. 91), except that the exterior was dyed light-brown rather than dark-blue and the interior decoration was dyed rather than painted. Once again, the coat is displayed inside-out to show the design. The motif is a phoenix and paulownia tree. As mentioned previously (see cat. 79), the Far Eastern phoenix differs from the Western phoenix in every way except that both are mythical birds. The Far Eastern phoenix (*hōō*) dwells only in countries enjoying peace and prosperity; it nests only in paulownia trees (*kiri*). The auspicious presence of the phoenix in the fireman's coat invites peace and prosperity, not only for the fireman himself but for the community in which he serves. As with the designs on our quilt covers (see cat. 78, 79, 81), this phoenix was created by the *tsutsugaki* technique, paste-resist dyeing in which the linear portions were drawn by hand using a paste applicator similar to a pastry cone.

94. Fireman's Coat
Stencil-dyed leather
H. 49¼″, W. 53½″
Meiji Period, 19th century
Purchase 12.83

Because of the Buddhist prohibition against taking life, leather was not widely used in Japan until modern times. Nevertheless, samurai used stencil-dyed deerskin extensively on their armor and other accoutrements. The deerskin was dyed by smoking, which turned it a warm, orangish-brown color. The technique was introduced to Japan from India in about the 5th century; it is still called *inden*, an old Japanese word for India. The design could be reserved in white by blocking part the surface with a stencil, as we see here, or the design could be stenciled on with ink or colored dyes.

During the Edo Period (1615–1868), *inden* was also used for tobacco pouches and coin purses. The use of leather by commoners was banned by the Tokugawa government in the middle of the Edo Period, not for religious reasons but as a sumptuary measure. Leather became popular again during the Meiji Period (1868–1912). *Inden* was fashionable for fireman's coats. This type was too valuable to wear while fighting fires but was ideal for ceremonial use, such as the annual parades staged by the volunteer fire companies. The *mon* (crest) on the upper back is the logo of the fire company; the design on the lower half is composed of stylized ideograms.

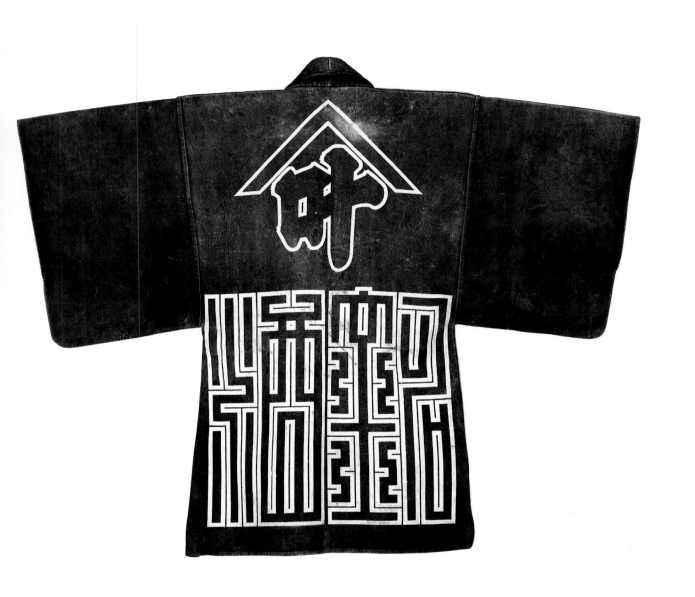

159

95. Fireman's Hat
Stencil-dyed leather
H. 22", Diam. 7½"
Meiji Period, 19th century
Gift of Dr. & Mrs. John Lyden 84.139.1

This is precisely the type of ceremonial cap worn with the preceding coat (see cat. 94). The hat bears *mon* (crests) of the fire company on each side of the hood, on the visor, and two more inside the hood. The leather was dyed orangish-brown by smoking (*inden*) with the crests reserved in white by means of stencils. Leather fireman's caps like this are extremely rare; very few have survived the ravages of insects and mildew. This one may be the only example in an American collection.

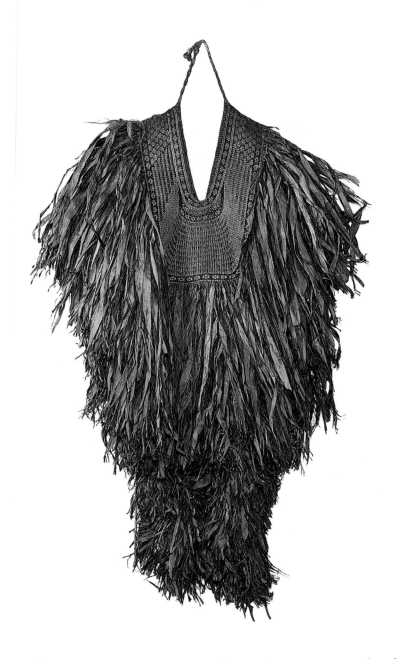

96. Mino (Straw Raincape)
Bark and straw
H. 65", W. 49"
Meiji Period, 19th century
Gift of Ty and Kiyoko Heineken 75.171

Straw raincapes were produced in almost every prefecture, but materials and styles varied. This one comes from Akita Prefecture, on the coast of the Japan Sea in the Tōhoku District of northeastern Honshū. The yoke, which is woven in elegant patterns, is made of hemp string and rice or barley straw. The rest of the cape is made from strips of bark called *okkagawa*.

OKINAWAN FOLK ART

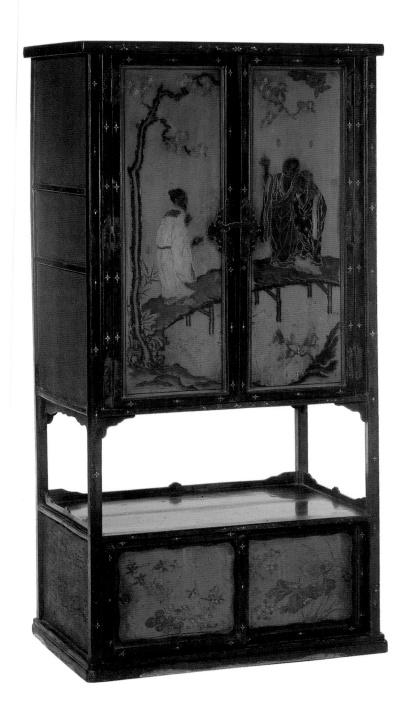

97. Cabinet

Lacquer on wood
H. 64⅛", W. 32"
18th century
Lent by Dr. Joseph Fortner L82.70

The Ryūkyū (Chinese: Liu-ch'iu) Islands form a crescent-shaped archipelago swinging southwest from the southern tip of Japan all the way to Taiwan. Okinawa is the largest of the fifty-five islands and also gives its name to the entire chain. For five hundred years (1372–1879) the Ryūkyū Islands were a nominally autonomous maritime kingdom with their own distinctive culture. Their location between the Pacific Ocean and the East China Sea, their proximity to China, the link they provided between Japan and Korea in the north and the Philippines and Indonesia to the south, as well as the warm and cold currents that sweep north and south past them, all contributed to the outstanding success of their merchant fleet in international trade. Okinawan ships sailed as far as Southeast Asia and even to the Persian Gulf, where they made contact with Arab and Portuguese traders, among many others.

Groups of peoples, trade, and cultural exchange must have moved up and down the Ryūkyū archipelago since the late Stone Age. In historic times, Chinese *Annals of the Sui* Dynasty (589–618) mention Liu-ch'iu. The *Chronicles of Japan* written in 720 mention Yaku, an early Japanese name for the Ryūkyūs. In 1372, Hung-wu, the first emperor of the Ming Dynasty (1368–1644), having taken China by military force, demanded tribute and acknowledgement of suzerainty from the Ryūkyū Islands. Chinese from Fukien Province were sent to Okinawa as permanent supervisors. In return, China offered extensive trade and some protection against Japanese and Korean pirates. In 1389 the king of the Ryūkyūs sent an embassy to Korea.

In 1451 a Ryūkyūan embassy to Japan was received in Kyoto by the Shōgun, Ashikaga Yoshimasa. However, in 1609 Shimazu Iehisa, the *daimyō* of Satsuma Province, attacked Okinawa in reprisal for the ill treatment of some Japanese fishermen shipwrecked there.

He captured the castle town of Shuri, then annexed the northernmost group of Ryūkyū islands to his fief. After that, Okinawa had to pay tribute to both China and Japan.

Following the Meiji Restoration of 1868, the entire Ryūkyū archipelago was annexed to Japan in April 1879. It became Okinawa Prefecture. China, too feeble at the time to do anything else, protested to the United States. Ex-President Grant was asked to arbitrate; he decided in favor of Japan.

Lacquer ware from the Ryūkyū Islands has been famous throughout the Far East since early times. Like so many aspects of Okinawan culture, the form and style of the lacquer objects is closer to Chinese than to Japanese types. Yet Okinawan lacquer has a mellow character all its own. This cabinet is a splendid and unusually large example. Much of the known surviving Ryūkyū lacquer belongs to the Tokugawa Museum in Nagoya, since the Shōguns were avid collectors of this ware. Many pieces of Okinawan lacquer in Western collections have been mistakenly attributed to China, and a few to Japan.

The scene on the main doors of this cabinet illustrates a classic Chinese story, one that is often depicted in Japanese art as well. The story is called "The Three Laughers at Tiger Creek" (Chinese: Hu-ch'i San-hsiao; Japanese: Kokei Sanshō). The priest Hui Yuan taught at Tung Lin temple on Mt. Lu during the 4th century. He vowed never to leave the mountain and would only escort his departing visitors as far as the bridge over Tiger Creek. The poets Tao Yuan-ming and Liu Hsiuching often came to visit him. One day as they were leaving, the priest was so absorbed in conversation that he walked right across the bridge with them. When they all realized what he had done, they stopped and had a good laugh.

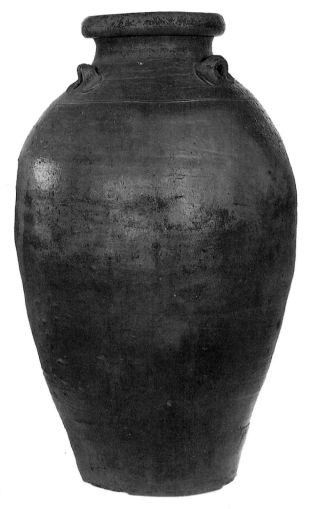

98. Storage Jar
Stoneware
H. 25", Diam. 13½"
18th century
Lent by Dr. & Mrs. Malcolm
 Idelson TL1983.300.7

Here we have a splendid example of a Ryūkyū *namban* (southern barbarian) jar. In Japan and Okinawa, storage jars made in Southeast Asia or South China were called *namban* jars because they arrived from the south, usually as shipping containers for various imported products. These imported *namban* jars were extensively imitated in locally made Okinawan storage jars. They were also copied to a certain extent in Japan, especially for tea-storage jars.

In the 15th century, the Ryūkyū Islands imported *awamori* (distilled millet liquor) from Thailand. The product was shipped in jars made at the Sawankhalok kilns in Thailand or at various kilns in South China.

The Okinawans soon learned from the Thai how to make their own *awamori*. They also began making their own storage jars, copying them from Thai or Chinese ones. The Okinawan jars are called Ryūkyū *namban*. The Chibana Kiln near Chibana Castle in the Mizatu area, slightly south of the midpoint on Okinawa Island, was a center for the production of these utilitarian jars. The neck, lip, and loop handles (for securing the paper cover over the wood stopper) imitate a Sawankhalok prototype almost exactly, but whereas Thai jars have a plump, oval profile, Okinawan ones are more columnar, as we see here.

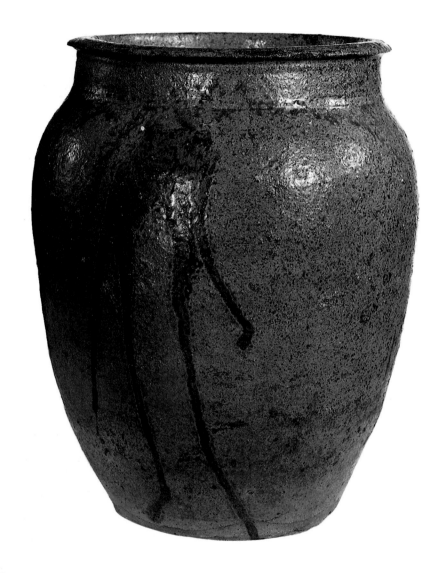

99. Wide-Mouthed Jar
Glazed stoneware
H. 13″, Diam. 9½″
17th–18th century
Lent by Dr. & Mrs. Malcolm Idelson TL1983.300.6

Until modern times, utilitarian ceramics were an important part of the daily life of the Okinawan people. They were called *arayachi*. Many were unglazed, like the preceding example; others were glazed, like this one, which has an olive-colored ash glaze and is decorated with a ladled splash of underglaze iron-brown on three sides.

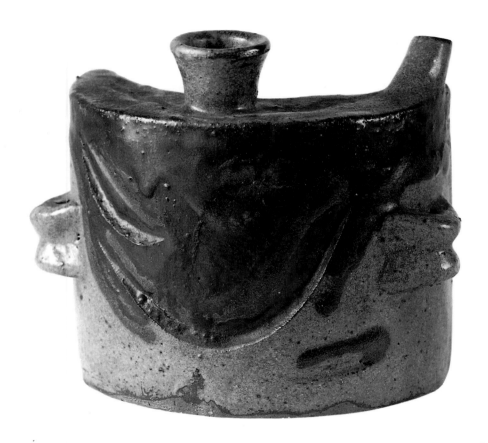

100. Dachibin (Hip Flask)
Glazed stoneware
H. 4⅞", W. 5½"
19th–20th century
Gift of Dr. & Mrs. John Lyden 84.196.12

The *dachibin* is unique to Okinawa. It functioned like a canteen, with a loop on each end to accommo- date a shoulder cord, a filling mouth in the center, and a small spout at one end to direct a stream of water, or liquor, into the wearer's mouth. Seen from the top, a *dachibin* has a crescent-shaped plan, to conform to the curve of one's hip. This example has an olive-colored ash glaze and is decorated with ladled splashes of dark-green and gray-black overglaze.

101. Ewer
Glazed stoneware
H. 3⅛", L. 4⅝"
Contemporary, c. 1970
Gift of Sidney Cardozo 80.175.7a&b

Whereas Okinawan *arayachi* is rough, utilitarian ceramic ware, *uwayachi* is more refined and more carefully decorated. Typically, an *uwayachi* piece has most of its coarse red clay surface covered with white slip under a clear glaze, as we see here. This white slip fires a warm ivory color, which is one of the great joys of Okinawan ceramics.

Much slipware has been produced in China, and some in Japan, but slipware was a major specialty in Korea, especially during the early Yi Dynasty (the 15th–16th centuries). A direct link exists between this Korean slipware and that of Okinawa. When the Japanese dictator Toyotomi Hideyoshi invaded Korea in 1592 and 1597, his generals kidnapped villages of Korean potters and put them to work in their own fiefs on Kyūshū and southwestern Honshū. Several important Japanese ceramic traditions were founded by these transplanted Koreans. One such tradition was Satsuma Ware. When the *daimyō* (feudal lord) of Satsuma

Province invaded the Ryūkyū Islands in 1609, he annexed the northernmost group of islands to his fief. In 1617 the king of the Ryūkyūs invited three immigrant Korean potters from Satsuma Province to work in Okinawa and teach the local potters their techniques.

Tsuboya, not far from the capital city of Naha on Okinawa Island, has long been the main ceramic production center of the Ryūkyūs. Before World War II, Tsuboya boasted more than ten kilns making utilitarian ceramics and one kiln making the more refined variety. Since the war, there is one kiln for the *arayachi* and two for the *uwayachi*. Most contemporary Okinawan ceramics are produced at Tsuboya.

Ryūkyūan slipware often has incised decoration enhanced with subtle splashes of copper-green, iron-brown, or cobalt-blue underglaze, as we see here. A ewer like this is used to serve *awamori* (distilled millet liquor) or sake.

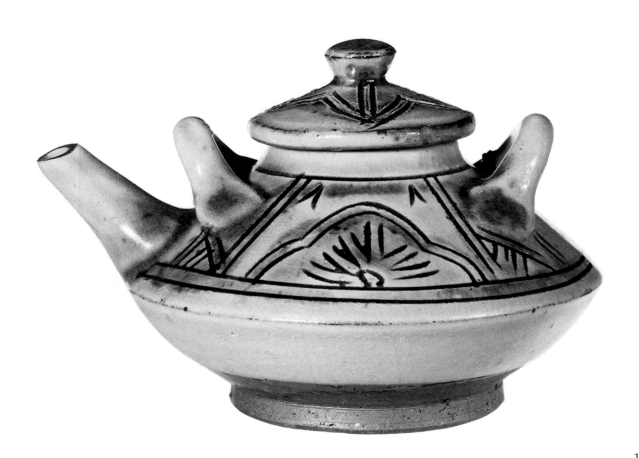

169

102. Bingata Kimono

Stencil-dyed cotton
L. 50", W. 48"
19th century
Purchase 12.889

Bingata is the famous multiple-color stencil-dyeing of Okinawa. It has created some of the most joyous fabric in the history of the world. The term is derived from *bini* (red dye) and *kata* (stencil). *Bingata* is produced by a combination of stencil paste-resist dyeing and free-hand paste-resist dyeing, using several colors. The technique was introduced to the Ryūkyū Islands from South China in the 15th century. It was promoted by the Okinawan royal court. Certain patterns and colors were restricted to the nobility and assigned according to court rank. Patterns of smaller designs and a predominantly blue color scheme were permitted for commoners.

Cotton is not native to the Ryūkyūs. Cultivation of the plant was introduced to Okinawa in 1611. The colors of the present robe are mainly red, yellow, and purple on a light blue ground. The crane and pine motif is a familiar symbol of longevity, an auspicious invitation of long life for the wearer of the robe or the person to whom it was given as a gift.

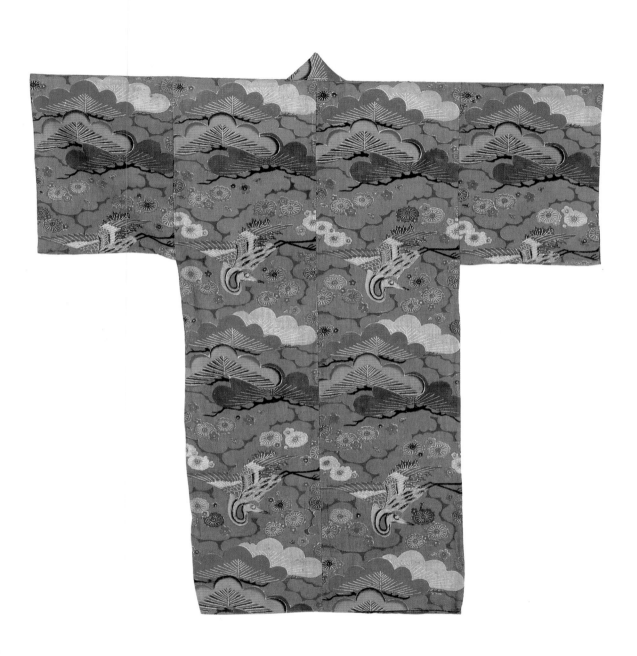

103. Bashō-Fu Kimono

Banana cloth
H. 49", W. 45"
19th century
Lent by Robert Anderson TL1984.167.2

Like cotton (see cat. 102), the banana plant is not native to the Ryūkyū Islands. It was brought to Okinawa from Taiwan or the Philippines in the 14th or 15th century. It soon became extremely popular. Cloth made from the fibers of the stalks is light, crisp, and cool, ideally suited to the tropical climate of the Ryūkyūs. *Bashō-fu* (banana-cloth) is the Japanese term for it; the Okinawan word is *bashā*. It is worn by all classes of people but was especially prized by common-

ers. The natural color of the cloth is a handsome light brown, as we see here. It was used plain, woven with stripes, woven with ikat designs, or dyed by *bingata* (see cat. 102). The stripes on this robe are a classic Okinawan design. The weaving of striped cloth was introduced to Japan from Okinawa in the 16th century. The Japanese word for "stripes" is *shima*, which also means "island," the islands from which the pattern came to Japan.

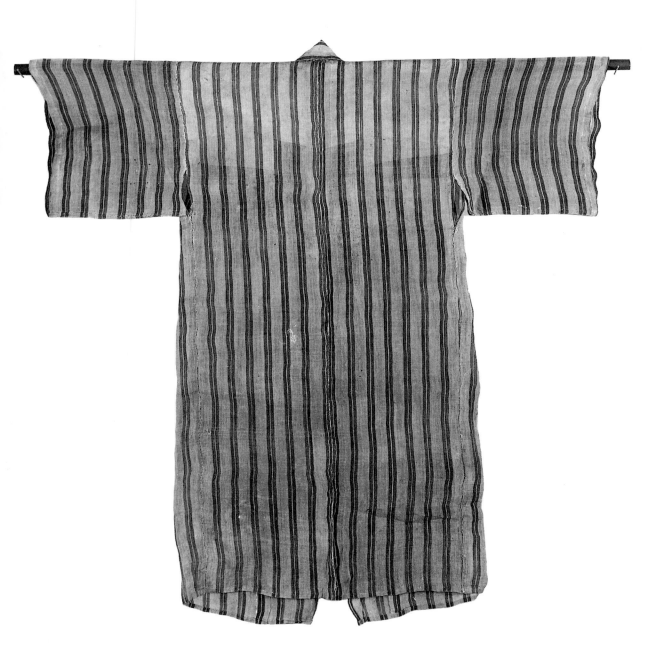

AINU ARTIFACTS
By Anne Pike Tay

THE AINU

According to Ainu lore, the ancestors of the Ainu came from the skies in a *shinta*, an Ainu cradle. They refer to themselves as Sky People. In ancient times, the Ainu were the aboriginals whom the Japanese referred to (both people and land) as Ezo or Yezo. Ainu place-names, such as "Fuji," and prehistoric archaeological evidence have led some scholars to believe that the Ainu once occupied all of Japan. Others suggest a more limited settlement area. In the recent past, the Ainu homeland consisted of the islands of Hokkaidō, the Kuriles, and southern Sakhalin; but in earlier historic times it included northern Honshū, northern Sakhalin, southern Kamchatka, and the lower Amur region as well.

Many questions arise concerning Ainu identity. From early times, the Japanese have noted through oral, written, and artistic means the two obvious aspects of Ainu physical appearance that set them apart from the Japanese: the tatooed lips of Ainu women and the "hairiness" of Ainu men. Ainu women began tatooing their lips and forearms at puberty and completed the process before their marriages. The tatoos were said to thwart evil spirits from entering the body of the wearer. As for the alleged overabundance of hair, the Ainu as a people have been no more hirsute than any given Caucasian population, but to eyes accustomed only to Japanese facial features, the Ainu did indeed appear "hairy." Some anthropologists suggest an Ainu affiliation with a people of Caucasoid stock, while others link the Ainu with the Mongoloid populations of Northeast Asia.

Ainu language is as distinctive and enigmatic as the people themselves. There is much confusion and debate about its linguistic affinities. This is compounded by the fact that four isolated languages surround the Ainu homeland—Ainu, Gilyak, Korean, and Japanese—all of whose genetic affiliations to other languages are in doubt or unknown. The difficulty of determining Ainu origins is exacerbated by the fact that we do not yet know the relationship of the present-day Japanese to the prehistoric populations of the Japanese archigelago.

In the 1800s, John Batchelor, a missionary among the Ainu for over fifty years, noted sadly that the traditional Ainu way of life was in decline and that the Ainu themselves were a fast-disappearing people. While the 1960 census of Hokkaidō registered some 17,000 Ainu, more than 95% of those were mixed Japanese and Ainu. In 1971 Hilger estimated that only three hundred full-blooded Ainu remained.

The climate of the Ainu homeland is severe, with snowfall from October through May. The mountains are heavily wooded, bear and deer roam the forests, and salmon run in most rivers from May until October. The tradi-

tional Ainu way of life was one of hunting and gathering. Deer, bear, and various marine animals were hunted for meat and skins. The major food resources were salmon, trout, and herring, eaten fresh in the spring and dried for the winter. While the men hunted, the women, with knowledge of every plant in the vicinity of their settlements, collected the many wild vegetables, roots, and seeds to supplement their diet.

Until the 19th century, contact with the outside world was limited to trade with the Chinese, Gilyak, Russians, and Japanese. The Ainu traded furs, eagle and hawk feathers, dried fish, and even Japanese ironware with the Chinese, from whom they received silk, beads, cotton material, needles, and pipes. Some of these items were in turn traded to the Japanese. From the Japanese the Ainu received tobacco, rice, rice wine, and ironware. Most of the foreign objects obtained by the Ainu, such as Japanese lacquerware or Manchurian brocade, were kept primarily as status symbol and offerings to the deities.

In 1656 the Ainu were incorporated into a system of restricted trade and feudal tribute by the Matsumae clan, which was subordinate to the Tokugawa Shogunate and occupied the southwestern tip of Hokkaidō. This exclusive control by the Matsumae clan resulted in unequal trade, increased Japanese immigration to Ainu territory, and exploitative gold mining. These factors led to Ainu uprisings in 1669 and 1789. The Tokugawa Shogunate ended Ainu independence in 1799, and former Ainu trading station became military outposts for protection against expanding Russian mercantile activities.

The Meiji Restoration established a colonial government in Hokkaidō in 1869 that accelerated the colonization of Ainu land. In order to encourage agriculture, a land-allotment program was instituted. This resulted in the displacement of territory traditionally set aside by the Ainu for seasonal hunting, fishing, and gathering. Laws for acculturation followed, forbidding the tattooing of women and the wearing of earrings by men, and making education in spoken and written Japanese mandatory.

The Ainu settlement or hamlet, known as the *kotan*, usually consisted of one to ten households. The homesteads were arranged according to cosmological principles.

The male elder of the family conducted family rituals for the ancestors. Many Ainu women were said to possess powers of prophecy, cure, and witchcraft. Even the simplest of household and daily activities was regulated by religious belief and ritual. Herein lies the major difference between Ainu crafts and Japanese folk art. Before the Western notion of the creative artist was introduced to Japan, the Japanese craftsman was simply doing his job by following his trade in an unselfconscious way. Whereas ritual practices, animistic beliefs, and the supplication of spirit powers were as integral to an Ainu robe or bowl as the weft threads or handle. The weaving of *attush* (elm-bark-fiber cloth) was women's work, as was the fabrication of *attush* garments and the application of their designs. Men carved wood and decorated their weapons and ceremonial objects with distinctive designs. Hunting, particularly bear hunting, required strict adherence to ritual. The bear itself is one of the supreme Ainu deities; *iomande*, the bear ceremony, is the best known Ainu ritual.

The religion of the Ainu was one of animism. Spiritual beings, *kamui*, were believed to be the beneficent essences within all of nature—within

mountains, animals, water, fire, oceans, trees, and fields. Human society was only a part of the universe in which good *kamui,* demons, and other beings dwelt. Much of Ainu behavior was directed toward pleasing deities and warding off demons. All humans, birds, plants, animals, and most man-made objects, had souls, or *ramat.* The Ainu were respectful to all soul bearers. Respect and ritual were therefore significant aspects of Ainu life.

BROOKLYN'S AINU COLLECTION

Early in 1912 the Brooklyn Museum acquired as a gift from Herman Stutzer the Ainu collection made by the anthropologist Frederick Starr of Chicago. Starr's collection had been compiled for display at the St. Louis Exposition of 1904. Later in the same year, on a collecting trip in East Asia, Brooklyn's curator Stewart Culin acquired more Ainu materials in Japan and the Kuriles. Culin also was able to procure some materials collected by the Rev. John Batchelor, the missionary working among the Ainu during the 1800s. Culin's collection essentially supplemented the Starr group.

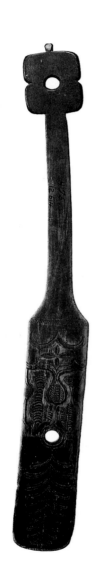

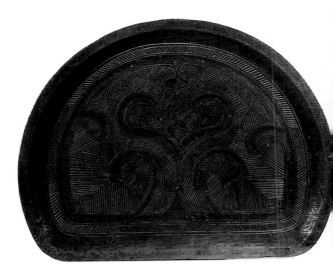

105. Carved Tray
Wood
L. 10", W. 12⅝"
Late Edo–Meiji Period, 19th–early 20th century
Collected by Steward Culin, Museum Expedition, 1912
12.669

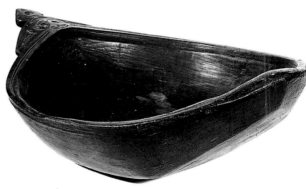

106. Bowl
Wood
H. 3⅜", L. 11¼"
Late Edo–Meiji Period, 19th–early 20th century
Collected by Stewart Culin, Museum Expedition, 1912
12.683a

104. Stirrer for Millet
Wood
L. 22", W. 2½"
Late Edo–Meiji Period, 19th–early 20th century
Collected by Steward Culin, Museum Expedition, 1912
12.614

Household objects—woodworking: The working of wood with the knife (*makiri*) was the exclusive right and duty of men. Art, religion, and utility merged in all Ainu activities. This is apparent in the beauty of form and incised design work of objects for daily use.

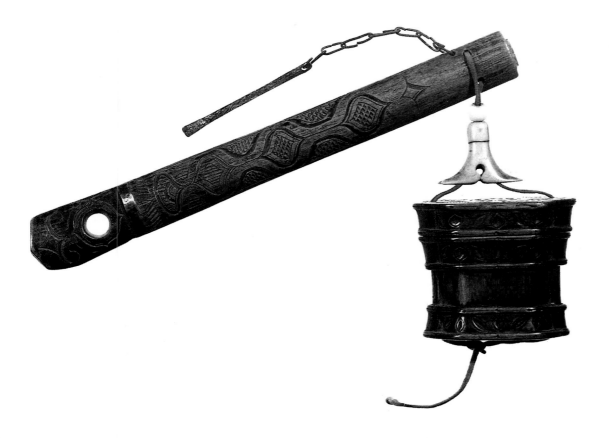

107. Tobacco Box and Pipe Holder
Wood, leather, bone, and metal
L. 21¼", W. 3⅝"
Late Edo–Meiji Period, late 19th–early 20th century
Collected by Stewart Culin, Museum Expedition, 1912
12.658

Tobacco boxes, carved by Ainu men, come in a variety of sizes, shapes, and design motifs. The well-loved tobacco mixture was a special blend that included rhododendron and bog rhubarb.

108. Group of Six Iku-Pashui (Ritual Drinking Spatulas)

Wood
Late Edo–Meiji Period, late 19th–early 20th century
(from left to right)
Lacquered
L. 13⅞", W.1¼"
Collected by Frederick Starr. Gift of Herman Stutzer.
 12.317
For *iomande* ceremony
L. 11⅜", W. ¾"
Collected by Frederick Starr. Gift of Herman Stutzer.
 12.307
L. 13⅝", W. 1"
Collected by Frederick Starr. Gift of Herman Stutzer.
 12.230
L. 13½", W. 1⅛"
Collected by Frederick Starr. Gift of Herman Stutzer.
 12.315
L. 13", W. ¾"
Collected by Stewart Culin, Museum Expedition, 1912.
 12.324
L. 15¾", W. 1⅛"
Collected by Frederick Starr. Gift of Herman Stutzer.
 12.282

Because an Ainu never drank wine without holding one of these spatulas in front of his nose, these implements were mistakenly called *higebera* (moustache-lifters) by 18th century Japanese observers. The pointe or slightly rounded end of the spatula was dipped into a cup of wine and moved up and down in front of the face, ritually offering wine to the *kamui* (spirits).

Ainu men carved *iku-pashui* from maple, dogwood oak, linden, and other hardwoods. Although they we usually left unpainted, some were sent to Japanese workshops for lacquering. There are seven kinds of *iku-pashui*, including certain types used for religious ceremonies and others used only by women and children. Ritual *iku-pashui* were often carved very simply and destroyed after use. The type made for the *ioman* (bear ceremony) has raised shavings suggesting the feathers of the bird it symbolizes.

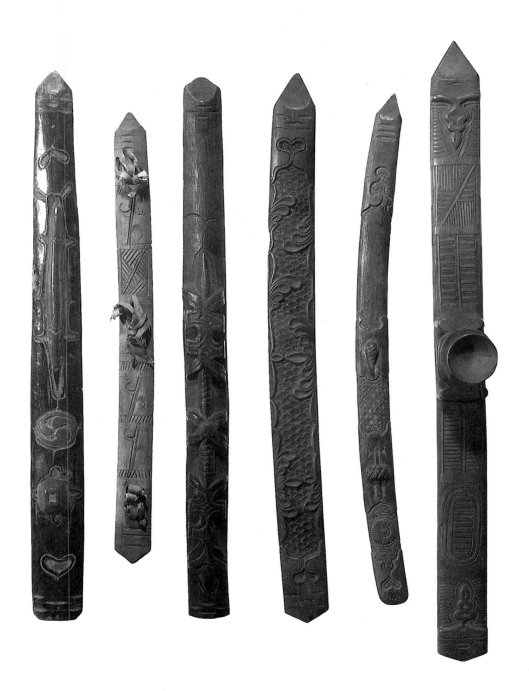

109. Sapa-un-pe (Man's Ceremonial Headdress)
Twisted willow shavings, wood, cloth
H. 2¾", Diam. 11⅜"
Late Edo–Meiji Period, late 19th–early 20th century
Collected by Stewart Culin, Museum Expedition, 1912.
 12.574

The wearing of *sapa-un-pe* by village elders was indispensable for religious ceremonies, protection against evil spirits, and solicitations to good spirits. This form of men's headgear was made from twisted willow shavings, willow being the Ainu tree-of-life. The headdress was reinforced and decorated with pieces of cloth; carved representations of creatures such as bears, foxes, eagles, falcons, or killer whales were attached to the front. The present example has two bear heads; the bear was the most revered deity in the Ainu pantheon. *Sapa-un-pe* headdresses were passed down from father to son.

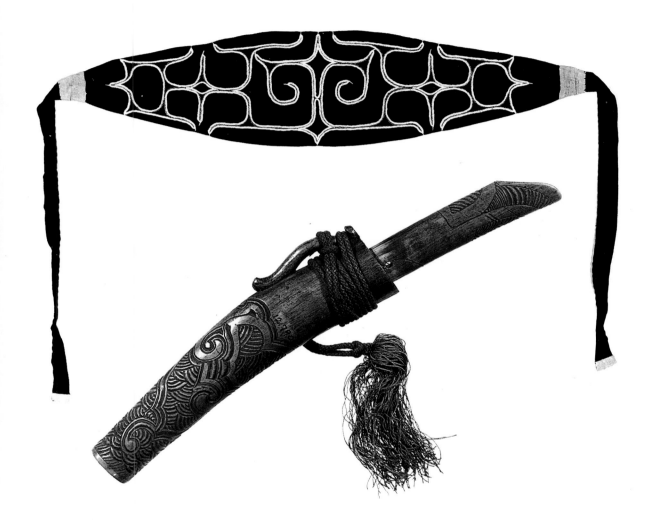

110. Knife in Sheath
Wood
L. 10⅝", W. 1½"
Late Edo–Meiji Period, late 19th–early 20th century
Collected by Frederick Starr. Gift of Herman Stutzer.
 12.790

111. Headband
Embroidered cotton
L. 22⅞", W. 6¼"
Late Edo–Meiji Period, late 19th–early 20th century
Collected by Frederick Starr. Gift of Herman Stutzer.
 12.790

Marriage: Soon after marriage the bridegroom was to make a knife sheath and handle, a spoon, a shuttle, and a weaving loom for his bride. The woman, in turn, made a headband, a belt, a necklace, and a pair of leggings, which she presented to her husband. This ceremonial exchange of *mat-eikara* (made for my wife) and *hoku-eikara* (made for my husband) served as a second pledge of marriage vows, expressing the couple's contentment in each other.

112. Woman's Robe

Attush (elm-bark-fiber cloth) with cotton and silk
 applique and embroidery
H. 49⅝", W. 52⅜"
Late Edo–Meiji Period, late 19th–early 20th century
Collected by the Rev. John Batchelor, Museum
 Expedition, 1912. 12.690

Ainu textiles: For the Ainu, the division of labor according to sex was precisely defined by the materials used. Wood was to be worked by men, textiles by women.

During the cold season, when men had relatively little to do, the women had to prepare the year's supply of clothing for their families. During the harshest part of the year, animal and fish skin garments were worn. But most of the clothing was woven from the fibers of the elm (Ulmus laciniata) or linden (Tilia japonica) trees in Hokkaidō, and also from the snow-bleached fibers of a nettlelike plant (Urtica thunberaiana) in Sakhalin. The Rev. John Batchelor, an early missionary to the Ainu, describes the traditional processing of the elm fibers on Hokkaidō during the latter half of the 19th century:

> Elm bark is peeled off the trees in early spring or autumn, just when the sap commences to flow upwards or when it has finished doing so. When sufficient bark has been taken, it is carried home and put into warm, stagnant water to soak. It remains here for about ten days till it has become soft; then, when it has become sufficiently soaked, it is taken out of the water, the layers of bark separated, dried in the sun, and the fibres divided into threads and wound up into balls for future use. Sewing thread is sometimes made in the same way, only it is chewed till it becomes round and solid. Sometimes, however, thread is made by chewing the green fibre as soon as taken from the trees. When all the threads have been prepared, the women sit down and proceed with their weaving.

When available, import materials from Honshū and China, such as cotton, silk, and ramie were readily utilized.

Ainu textile designs are manifest through various techniques of applique and embroidery. While they are always symmetrical, because of the free-hand manner of working and the shapes of the designs themselves, they are never static. On the contrary, the variations on the traditional motifs of spirals (moreau), thorns, and bracings seem alive with movement. The patterns on any given robe revealed to other Ainu such information as village or family, status, and sex of the owner. The Ainu did not prepare garments for special occasions, but for the bear ceremony everyone wore a newly prepared robe.

The present intricately worked robe exhibits both kinds of Ainu applique: *kiri-fuse* (cutting and applying) provides the larger and heavier patterns; *nuno-oki* (stitching ribbon-like bands of cloth) provides the softer patterns. The embroidery techniques employed here include *oki-nuki*, in which relatively thick threads are placed on the cloth ground and affixed by stitchwork. Several variations on the chain stitch were also used.

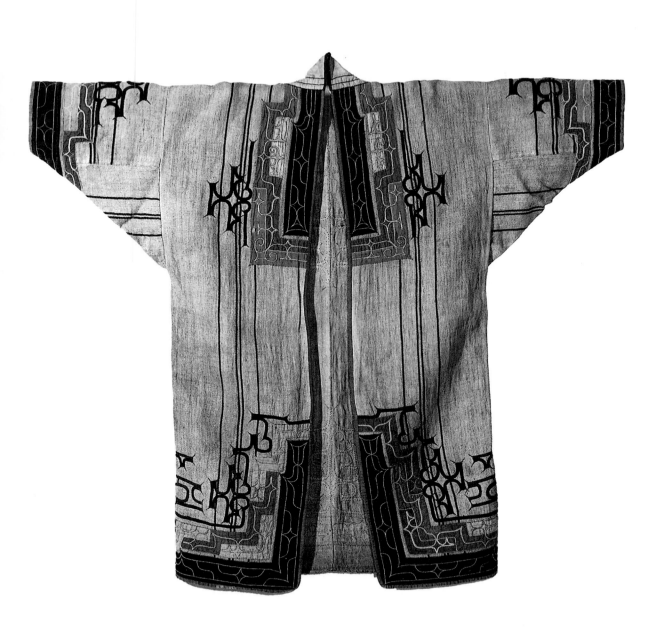

113. Man's Robe

Attush (elm-bark-fiber cloth) with applique
 and embroidery
H. 51⅛", W. 52"
Late Edo–Meiji Period, late 19th–early 20th century
Collected by Stewart Culin, Museum Expedition, 1912.
 12.656

This robe displays several variations on the chain stitch and on the traditional design motifs. For the Ainu, the placement of the designs so as to enclose the area of the neck, the sleeves, and the base of the garment prevented evil spirits from entering the wearer's body.

MINGEI: JAPANESE FOLK ART

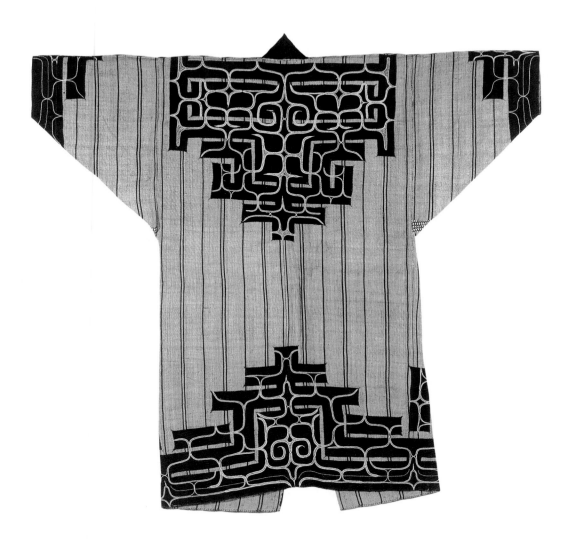

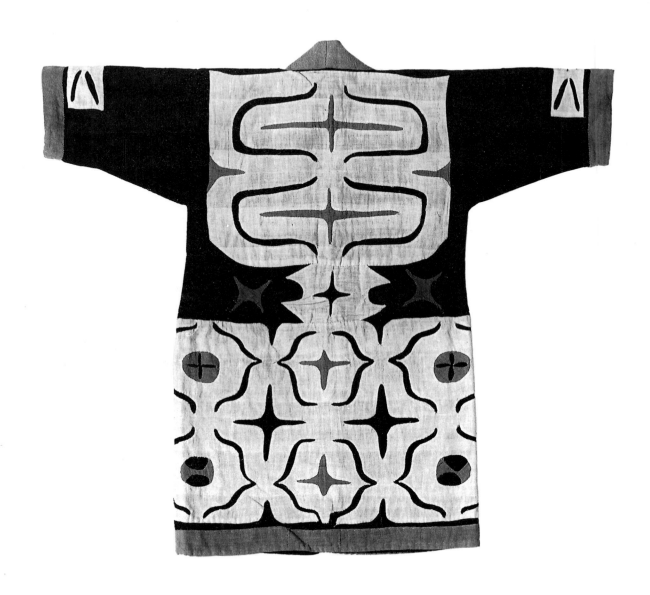

114. Child's Robe
Cloth with applique
H. 31½", W. 33½"
Late Edo–Meiji Period, late 19th–early 20th century
Collected by the Rev. John Batchelor, Museum
 Expedition, 1912. 12.746

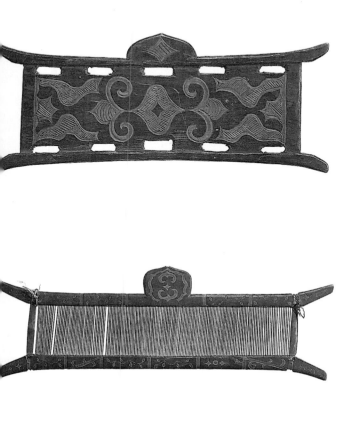

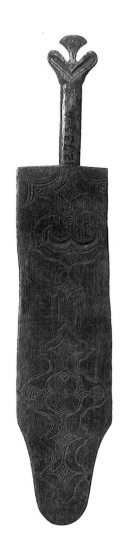

15. Three Weaving Implements

Warp Spacer / Shed Stick
Wood
L. 6¾", W. 2½"
Late Edo–Meiji Period, late 19th–early 20th century
Collected by Stewart Culin, Museum Expedition, 1912.
 12.733

Warp Spacer (*Osa*)
Wood and twine
L. 21½", W. 6¾"
Late Edo–Meiji Period, late 19th–early 20th century
Collected by the Rev. John Batchelor, Museum
 Expedition, 1912. 12.737

Beater-in / Shuttle
Wood
L. 12⅛", W. 2¼"
Late Edo–Meiji Period, late 19th–early 20th century
Collected by Stewart Culin, Museum Expedition, 1912.
 12.735a

SELECTED BIBLIOGRAPHY

Batchelor, John. **Ainu Life and Lore: Echoes of a Departing Race**. Tokyo: no publisher's name given, 1927.

Cort, Louise. **Shigaraki, Potters' Valley**. Tokyo, New York, and San Francisco: Kodansha International, 1979.

Dusenbury, Mary. **Kasuri: A Japanese Textile**. Washington, D.C.: The Textile Museum, 1978.

Hauge, Victor and Takako. **Folk Traditions in Japanese Art**. New York: John Weatherhill, 1978.

Heineken, Ty and Kiyoko. **Tansu: Traditional Japanese Cabinetry**. New York and Tokyo: Weatherhill, 1981.

Hickman, Money, and Peter Fetchko. **Japan Day by Day: An Exhibition in Honor of Edward Sylvester Morse**. Salem, Mass.: The Peabody Museum, 1977.

Jenyns, Soame. **Japanese Pottery**. London: Faber and Faber, 1971.

Joly, Henri. **Legend in Japanese Art: A Description of Historical Episodes, Legendary Characters, Folk-Lore, Myths, Religious Symbolism, Illustrated in the Arts of Old Japan**. Rutland and Tokyo: Tuttle, 1967.

Kudō, Kazuyoshi. **Japanese Bamboo Baskets**. Tokyo, New York, and San Francisco: Kodansha International, 1980.

Kyoto, The National Museum of Modern Art. **Craft Treasures of Okinawa**. Tokyo, New York, and San Francisco: Kodansha International 1978.

Levy, Dana, and Lea Sneider. **Kanban: Shop Signs of Japan**. New York: Weatherhill, 1982.

Massy, Patricia. **Sketches of Japanese Crafts and the People Who Make Them**. Tokyo: The Japan Times, 1980.

Mizuo, Hiroshi. **Famous Ceramics of Japan 3: Folk Kilns I**. Tokyo, New York, and San Francisco: Kodansha International, 1981.

Munro, Neil G. **Ainu Creed and Cult**. New York: Columbia University Press, 1963.

Munsterberg, Hugo. **The Folk Arts of Japan**. Rutland and Tokyo: Tuttle, 1958.

Muraoka, Kageo, and Kichiemon Okamura. **Folk Arts and Crafts of Japan.** New York and Tokyo: Weatherhill/Heibonsha, 1973.

Ohnuki-Tierney, Emiko. **The Ainu of the Northwest Coast of Southern Sakhalin.** New York: Holt, Rinehart and Winston, 1974.

Okamura, Kichiemon. **Famous Ceramics of Japan 4: Folk Kilns II.** Tokyo, New York, and San Francisco: Kodansha International, 1981.

Rathbun, William, and Michael Knight. **Yō no Bi: The Beauty of Japanese Folk Art.** Seattle: University of Washington Press, 1983.

Rhodes, Daniel. **Tamba Pottery: The Timeless Art of a Japanese Village.** Tokyo, New York, and San Francisco: Kodansha International, 1970.

Saint-Gilles, Amaury. **Mingei: Japan's Enduring Folk Arts.** Tokyo: Published by the author, 1983.

Sanders, Herbert. **The World of Japanese Ceramics.** Tokyo, New York, and San Francisco: Kodansha International, 1968.

Sonobe, Kiyoshi, and Kazuya Sakamoto. Translated by Charles Pomeroy. **Japanese Toys: Playing With History.** Tokyo and Rutland: Bijutsu Shuppan-sha and Tuttle, 1965.

Sugimura, Tsune, and Hisao Suzuki. **Living Crafts of Okinawa.** New York and Tokyo: Weatherhill, 1973.

Yanagi, Sōetsu. **The Unknown Craftsman: A Japanese Insight into Beauty.** Tokyo, New York, and San Francisco: Kodansha International, 1972.